Further Adventures in The Simpsons™ Collectibles

An Unauthorized Guide

Robert W. Getz

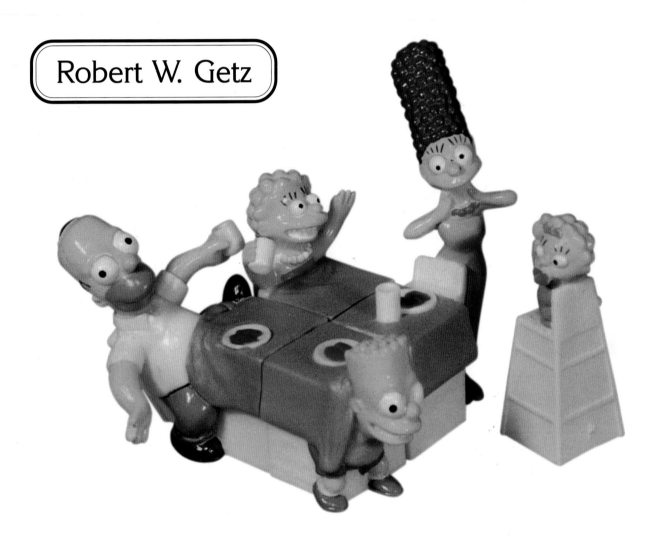

Schiffer Publishing Ltd

4880 Lower Valley Road, Atglen, PA 19310 USA

Dedication

For Rebecca and John

The Simpsons™, created by Matt Groening, is a trade-marked and copyrighted property of Twentieth Century Fox Film Corporation. This book has neither been approved nor authorized by Twentieth Century Fox, Bongo Entertainment, Inc., Matt Groening Productions, Inc., or any of the entities involved in producing The Simpsons and is not meant in any way to infringe on any trademark or copyright. It is based on the author's independent research and intended to provide information for collectors.

"Yellow Fever!" originally appeared in another form in *Collectors' Showcase*. I thank them and Chris Greer for allowing me to reprint it here.

Copyright © 2001 by Robert W. Getz
Library of Congress Card Number: 00-109504

Designed by "Sue"
Type set in Humanist 521 BT/Korinna BT

ISBN: 0-7643-1231-6
Printed in China
1 2 3 4

Published by Schiffer Publishing Ltd.
4880 Lower Valley Road
Atglen, PA 19310
Phone: (610) 593-1777; Fax: (610) 593-2002
E-mail: Schifferbk@aol.com
Please visit our web site catalog at **www.schifferbooks.com**
We are always looking for people to write books on new and related subjects. If you have an idea for a book, please contact us at the above address.

This book may be purchased from the publisher.
Include $3.95 for shipping.
Please try your bookstore first.
You may write for a free catalog.

In Europe, Schiffer books are distributed by
Bushwood Books
6 Marksbury Avenue
Kew Gardens
Surrey TW9 4JF England
Phone: 44 (0) 20 8392 8585
Fax: 44 (0) 20 8392 9876
E-mail: Bushwd@aol.com
Free postage in the UK. Europe: air mail at cost.

Contents

Acknowledgments

An annoyed grunt and many thanks to the following people:

To my mother and father; To Steve Goldberg, whose enthusiasm is greatly missed: we're saving the promos for you; To Bob Delvishio, who still understands "the collecting problem" better than anyone: I'm glad you're still there; To Doug Baptie, George Bond, Mike Nagle, Carl Clauss, and Phil and Sarah Stokes for keeping my phone and e-mail warm; To everyone at Cyborg One in Doylestown, Pa. and Joys and Toys in Hatboro, Pa.; Thanks to everyone who helped fill up the book this time around, including: James Boryla for the Mexican figures; David Richards for his great patience and help with items from Germany and Belgium; Peter and PB Toys from Germany; Nobby Coburn for his helpful list of the Bongo promo pins and saving me several

trips to San Diego; Mark Tarses of Sunway Co., whose one-stop online shopping saved me hours of searching; Victor J. Medcalf for providing many of the items from the U.K.; Mike Seigworth for the Suncoast posters; Thomas Sestak for help with the Pez; Gunter and Susanne in Australia; Ian Wallace in the U.K., who provided invaluable, last-minute assistance with the new U.K. Burger King figures; Maria Rosati, who came through with the Dolcerie Veneziane set: Grazie!; True blue (or yellow?) Simpsons nut Richard from the U.K.: Where are you?; and Greg Joseph for his hospitality during our home invasion; To Bill LaRue, whose *Collecting Simpsons!* website always shows me something I haven't seen before; To Bill Morrison, a nice guy like they don't make anymore, whose kindness and generosity have astonished me; To Mike, Dan, Lena, Alyssa, and new additions Jack and Jessica, who have proven themselves larval vessels to contend with; A special thanks to Dawn Stoltzfuz for shepherding the previous volume into print: she let it be the book I wanted it to be; To Peter Schiffer, whose assurances did much to

calm my first-time jitters; To Bruce Wodder, for the photograph; And to Milt Gross, George Herriman, Walt Kelly, and Matt Groening for all of the inspiration.

Once again, a low bow to Rebecca Greason and John Hein, who signed up for another hitch on the S.S. Spiky. Rebecca took all of the photographs you see here, with the exception of the handful that I tried this time out and which you will readily be able to identify (apologies to both Rebecca and Greg Joseph). Thanks again for your patience and grace under pressure. This is the last one, promise.

Finally, to Sheva Golkow, who's shared every bump in the road these two books represent. Without you, as the saying goes, I'm nothing. Whenever I'm done playing Homer, you always lead me home. The first thousand years are the hardest, but if I've ever helped make the road a smoother one for you, then I'm happy. I love you very much and I can say that, even in the most difficult circumstances, you make my life a joy. Thanks for showing me so much. This is the century we've been waiting for: the cookie told me so.

Simpsonamilabillennium: or Welcome to the World of Tomorrow!

. . . an infant so fully independent that he never plays a part to please his parents, never puts on a mask his elders have designed.
—Lewis Hyde, *Trickster Makes This World*

The carcass of the Simpsons empire had been picked clean.
—*Simpsons* Season Finale, 2000

Welcome back.

The book in your hands is intended as a sequel to *The Unauthorized Guide To The Simpsons Collectibles,* a guide to Simpsons memorabilia that Schiffer Publishing issued in 1998. It's intended as a supplement to that noble volume, something to fill in the gaps in the previous guide as well as bring it up to date. Like most sequels, this one will neither reach the heights, nor plumb the depths, of the original. Instead, it will offer a reassuring supply of the same, breaking no new ground while remaining steadfastly familiar. And speaking of television . . .

Bartonomy Vs. Ottocracy

As the year 2000 approached, you could hear centuries of civilization begin to mutter, Moe-like, to themselves. Some prophesied doom; others said we were on the verge of a new golden age. Some feared an international collapse of commerce; others saw Mankind making an evolutionary leap. We looked for the proper way to commemorate the occasion. Should we see the new century boldly in at the edge of the world? Or should we stay at home instead, among family and friends, giving thanks for the simple things? Would this new millennium be an

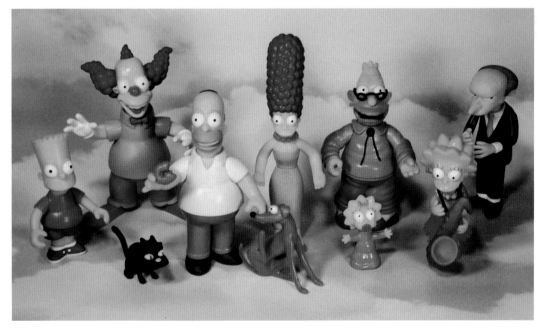

The traditional clouds part on the new millennium and the first wave of Simpsons "Intelli-Tronic" figures.

era of vandalism or creativity?[1] Would some magic switch be thrown that would allow our leaders to find common ground, ushering in peace and prosperity? Or would we regress even further, producing even more lip-synching teenpop and trash talk shows? A virtual Milli Vanillium?

When the first day of 2000 dawned, however, there was something familiar about it. Those large circles trailing breathlessly after the numeral 2 . . . didn't they faintly resemble two bulgy eyeballs? And that last one, if you looked at it just right, didn't it look sort of like a . . .

Donut?

That's right. Among the many other things it heralded, the fledgling century marked the tenth anniversary of *The Simpsons*. It was hardly a milestone that was going to go uncelebrated. It started off with them getting their own star on the Hollywood Walk of Fame and each month that followed brought some new cornucopia of collectibles: candy dispensers, talking action figures, games, and toys. The sheer amount of it was overwhelming. Wave after wave of merchandise materialized, unbidden. It felt as if the inmates were finally running the asylum and there was no collector's wish too wild to go unfulfilled. Interactive action figures? Cool, Man. Shorts-shaped snacks? Sure, Dude. Charcoal Grill? No Problemo! After hundreds of years of artistic expression and scientific discovery, the new millennium boiled down to this: we were living in the greatest era *Simpsons* collectors had ever known.

At the risk of sounding immodest, it's worth noting that much of this activity has come after the publication of my first book, *The Unauthorized Guide To The Simpsons Collectibles*. Consider the following facts:

Before the *Guide*: *Simpsons* collectibles languish lonely and forgotten in attics and basements around the world. TV show is only dimly remembered, if at all, as some endless cycle of reruns popular with older viewers who enjoy the antics of Abe "Grampa" Simpson. After the *Guide*: Kids begin to identify with show's "bad boy" character, Bart. New *Simpsons* collectibles extremely popular, sell out of stores.

Before the *Guide*: *Star Wars* collectibles and Beanie Babies are hot commodities, commanding high prices on the secondary market. After the *Guide*: Beanie Babies become as popular as Jar Jar Binks.

Before the *Guide*: Humans travel in nomadic tribes and regard the sun and other heavenly bodies with suspicion. After the *Guide*: People routinely wish each other "a nice day." "Please" and "thank you" begin to work their way back into our daily lexicon. Strangers begin to respond to my telepathic commands.

Much of this could be explained away as coincidence but the amount of evidence is compelling. At any rate, it's fair to say that *Simpsons* collectibles have certainly leapt back into the spotlight in a big way in the last few years. Thanks in part to *The Simpsons Global Fanfest*, a year-long celebration of the show, fans can now find

Simpsons toys and games on U.S. shelves again and there's lots more to come.

In March of 2000, a new era in *Simpsons* collecting began when Playmates released the first wave of *World Of Springfield* "Intelli-tronic" figures. What really bum rushed the adrenaline in fans was the promise implicit in the phrase *World Of Springfield*: namely, that characters outside of the Simpson family would finally be getting their due. Dreams of Otto and Chief Wiggum figures would be transformed, at long last, into reality. One month there was no such thing as a Mr. Burns figure. The next month there were three. When you stop to consider that a popular *Simpsons* poster features over three hundred different characters, the possibilities of the *World Of Springfield* become limitless. What fan wouldn't want a Comic Book Guy? Or a Sideshow Bob? How about Ned Flanders in his devil suit? Or Zombie Shakespeare?[2]

Anything You Can Do Icon Do Better

It feels like an awful lot has happened since the first volume of *Simpsons Collectibles* appeared, even though it's only been a couple of years. Part of that is the renewed attention the subject seems to be getting, not to mention the critical kudos the show is consistently receiving as a sort of elder statesman of sitcoms. In fact, *The Simpsons* now receives so much respect that you're tempted to wonder if you haven't misjudged it. Have no fear, though: it's simply a measure of the affection in which the show is held by so many people from so many different walks of life. Testimonials abound, from Stephen Hawking[3] to the punk rockers who wondered what *The Stonecutters Song* would sound like performed hardcore style.[4] If the psychic will of an audience has any power, we may never see the end of *The Simpsons*. And if they must go someday, we're hedging our bets by trying to bring as much of Springfield into Our World as we can. We've got skateboards for Bart, should he care to Bart our world. We've got shot glasses for Barney, should he care for an aperi-blaaap!-tif. We've even got a charcoal grill for Homer, ready and waiting to be anointed by his four-fingered hand. Creating a *World Of Springfield* only makes overt what we always suspected: *we're* the ones who want to live in *their* world.[5]

The Simpsons itself seems to have crossed a threshold of sorts. Having survived some real-life difficulties in recent years that might have spelled the end for other shows, it's gone on, changing all the time, but not so far that we feel like we're watching a different show. It's become commonplace to note that movies and video games[6] have made such incredible leaps in special effects recently that more static forms of entertainment, such as comic books, are finding it more difficult to attract an audience. It's surely a compliment that a show

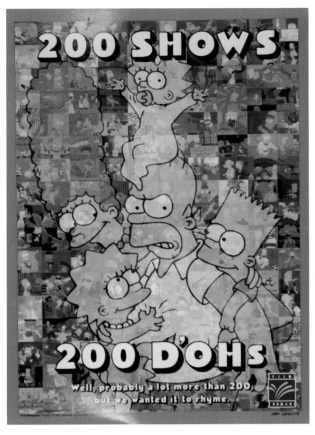

Film Roman ad celebrating the 200th episode of *The Simpsons*.

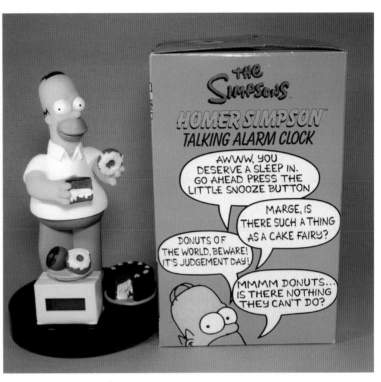

Homer Talking alarm clock from Wesco.

like *The Simpsons* has not only managed to retain its audience in this kind of environment, it's also prospered. If the wealth of retrospective articles inspired by the show's 10th anniversary prove anything, it's that the show is not a footnote.[7] It's a major twentieth century icon, up there with anything you care to name. Monroe's skirt, meet Marge's hair. When you think late twentieth century pop culture, you're thinking *D'oh!* Maybe you knew it, but 2000 was the year everyone knew it.

At any rate, I'd like to take a moment to thank everyone who welcomed the first *Unauthorized Guide* into their homes, especially those who took the time to tell me what they thought of it or who reviewed it in print or online. Some of the things you had to say were kinder than we could have hoped for and made all the work feel justified indeed. If there was one point on which reviewers split, though, it was the book's introduction, a little off the beaten path where most price guides were concerned.[8] On the other hand, for some readers it was the thing they liked the most, so go figure.[9] And to the person who wrote on Amazon.com that the book "touches the reader emotionally," know that I don't expect to ever receive any higher praise than this.[10]

Part of that introduction tried to make a case for Bart Simpson as an American archetype, a modern Huck Finn who expresses something intimate, yet inexpressible, about the American spirit.[11] In addition, creator Matt Groening has invoked titles such as Thomas Bailey Aldrich's *The Story of a Bad Boy* and Henry A. Shute's *The Real Diary of a Real Boy* when discussing Bart's origins. In the final analysis, Bart may be a much more ancient figure, namely *Trickster*, that figure of myth and oral legend that Lewis Hyde, in his excellent 1998 book *Trickster Makes This World: Mischief, Myth and Art*, defines as "a boundary-crosser . . . in every case, Trickster will cross the line and confuse the distinction. Trickster is the creative idiot, therefore, the wise fool, the gray-haired baby, the cross-dresser, the speaker of sacred profanities." Elsewhere, Hyde writes, "Moreover, to work in his spirit is to be less obedient to 'the parents,' less likely to be drawn into their tasks. When (he) returns from his night of thieving, his mother chastises him; she has a clear image of what he is and, by implication, an image of what she'd prefer him to be."

Bart flashlight from the U.K.

Strangest of all, perhaps, is Hyde's unintentional paraphrase of something I said in that same introduction. On the subject of Bart's "mayhem," I wrote that it was "…essentially harmless. It's more of an intellectual exercise for this pint-sized Professor Moriarty, pranks pulled for the sheer pleasure of seeing them work." Imagine the double-take I did when I read the following in *Trickster*: "When he lies and steals, it isn't so much to get away with something or get rich as to disturb the established categories of truth and property and, by so doing, open the road to possible new worlds." No wonder the mischievous critter resonates in that primal cave you call a skull. I recommend Hyde's remarkable book to anyone with an interest in where culture's been and where it's going. It seems strange to me, though, that in a book that manages to namecheck Robert Mapplethorpe and John Cage, there isn't any mention of Springfield's resident Trickster.

Remembrance Of Frinks Past

Recently, I bought a Special Edition DVD of Bob Clampett's *Beany and Cecil*. It's filled with all kinds of treasures: old kinescopes, behind-the-scenes material, and, of course, the cartoons themselves. In addition, there was a section that pictured the show's merchandise and, as I looked at it, I felt a familiar thrill as I recalled how much of it I'd owned as a child. Like the cartoons, the items looked strange and intimately familiar at the same time, as if I'd had this pocket of Proustian memory hidden away for years that only needed a picture of a propeller beanie to be unlocked. I understood instantly that my collecting The Simpsons was just another manifestation of something that had been hard-wired into me at an early age. In fact, my earliest memory is of desiring a *Huckleberry Hound* board game, followed closely by re-membrances of a candy cane colored pen I'd pretend belonged to *Top Cat*.

I remember the sensuous joy of my *Batman* cards and that mild electric tingle I'd get when I added another missing card to the set. I remember the shelves of comic books whose arrangement by title and number satisfied something very primal. Where does the urge to archive come from? Is it a desperate attempt to impose order on a chaotic universe? Or is it the sense of inner completeness that results when a long prodigal collectible submits to your well-meaning instruction?

Maybe there's just something inside us that's uncomfortable abandoning the past. After all, if our past isn't worth anything, then it follows that the past we're destined to become has no value either, and that's simply unacceptable. Better to celebrate our own obsolescence, then, with flags of old newspapers and pulp magazines, scruffy floats of old tin toys, and batons rotating like mad shadows over the hemispheres. Detritus points our way down the hall of centuries like markers in a dark wood, no toy abandoned enough that it still doesn't contain a spark of love. Some human thing was here, it says, as you are here now. Life isn't terribly different and laughter never dies.

Which brings you and me to this uncomfortable precipice: staring down another thousand years.[12] Maybe those markers in the wood are meaningless. Maybe we don't progress so much as run in a circle on the floor. Names change, as do coastlines. Seas of summers follow fields of springs, only to have those summer winds scatter and disappear like a pair of abandoned swimming trunks. In the vastness of Time's margestic maggienificence, there's something uniquely Homerican about these strains of unpremeditated Bart. Lisa carefully and you can hear the annoyed grunt of a thousand years: Muntznickburnsfrinknedralphcarlrod! Here's to another thousand years of propeller beanies: may they lift us off the Earth as they have always done; may they take us where we've never been; may they make light children's hearts. Remember these days for your grandchildren's sake. Tell them to never put on a mask their elders have designed. And tell them you were there when the road to a new world, a world of Springfields, was opened.

P.S.: Don't forget to put this book in your time capsule and pass it down from generation to generation.[13] One day your genetically mutated descendants will be able to barter it for goods and services.

Robert W. Getz
June, 2000
Springfield, USA[14]

Endnotes

[1] The concept of a *millennium* was not news to anyone who had grown up with comic books: It was par for the course for a supervillain to announce that he had nursed his vengeance along "for untold millennia," especially in the space operas of Stan Lee and Jack Kirby that appeared in *The Mighty Thor* and *Fantastic Four*. *Eons* were also a popular time frame in which to hatch one's diabolical plan.

[2] And what is the deal with those *Spawn* toys? Have you seen these things? Are they supposed to be dinosaurs or what?

[3] Astrophysicist Stephen Hawking revealed on *Larry King Live* that he planned to throw a Simpsons Millennium Party to welcome 2000. The implications of our most profound thinker about the universe wanting to see in the most cosmic event of our lifetime with a Simpsons party are best not considered.

[4] It's no wonder that The Simpsons have always been punk rock favorites. Not only does Bart resemble an animated Johnny Rotten, but think about how natural it would sound to hear Homer moan bitterly, along with Joey Ramone, "D-U-M-B! Everyone's accusing me!"

[5] An article that appeared in *USA Today* (2/28/00) suggested that eBay mania may have gone too far: 14-year old Adam Fox of Las Cruces, New Mexico decided to put his soul up for auction on the popular website. "For a low price, you get a piece of paper saying you own my soul," he wrote temptingly. Fox said he had gotten the idea from *The Simpsons* and when he checked eBay and found soul auctions already going on, decided to try it himself. If you ask me, he should have held out for a donut.

[6] The full story of my *Donkey Kong* fixation is too lengthy to recount here. Let's just say that I've done my fair share of virtual vine swinging. And that Sheva eventually memorized, without any effort on her part, every music cue in the Kong family of games. And that I own the soundtracks on CD. And cassette. And that, after a while, my mental landscape began to resemble an uneasy cross between *Mighty Joe Young* and *Videodrome*. Unfortunately, my recent attempts to play the new generation of "3-D" games have been thwarted by a sort of motion sickness that works a lot like the Ludovico technique in *A Clockwork Orange*. So don't even ask about the whole *Blair Witch* thing. I lasted through about five minutes of that shaky-cam before bolting to the Men's Room. Hey, you know they made that whole thing up as they went along? It was a lot like my first book, only nobody ran screaming into the night. Well, almost nobody.

[7] Like, for instance, this one.

[8] Suffice it to say that not everyone was enchanted with that book's introduction and its odd compendium of flora and Flanders. Some of these complaints were ironic, seeing as how I never cottoned much to book-learning. I do, however, possess something known as "street smarts," which, as the phrase suggests, consists mainly of the ability to get from one side of the street to the other.

[9] Anyone who thought we went overboard is hereby directed to James Poniewozik's piece, *The Best TV Show Ever*, which appeared on *Time Magazine's* website (www.time.com) in late 1999. Poniewozik reckons *The Simpsons* is "great 20th-century art" and compares it to *Ulysses*, *The Godfather*, *Rhapsody In Blue*, Shakespeare, and Chaucer. This line of reasoning begs some other interesting questions: Does *Frasier* owe more to Molière or *My Little Margie*? Was the worldview of *Seinfeld* closer to Jonathan Swift or Jonathan Winters? And, lastly, what time is *Futurama* on this week?

[10] If I have any regrets about the intro, it's that I somehow neglected to mention the huge influence of John Kricfalusi on today's animated shows. Kricfalusi, famously dismissed from *The Ren and Stimpy Show*, may have gotten his foot in the door thanks to *The Simpsons*, but there's isn't a cartoon on the air today that hasn't borrowed from his elastic and innovative style. A purist who believes that cartoons should look like cartoons, with all of the anarchy and pandemonium that implies, Kricfalusi can't understand the appeal of *South Park* (which he summarily dismissed in an interview as "the triangles-on-sticks show") or any animated show that doesn't take full advantage of the medium. His own Bob-Clampett-Meets-Tex-Avery style can be exhausting but is ultimately exhilarating, a wild reflection of a barely contained imagination. Today Kricfalusi plies his trade on the Internet and produces occasional shorts and videos (see Bjork's *I Miss You*).

[11] In Greil Marcus' seminal volume of cultural criticism, *Mystery Train*, he relates the story of rock 'n' roll precursor Harmonica Frank. For Marcus, all of rock and roll, and much of American art, can be traced back to Frank's intention to show us his name "on the tail of my shirt." I mention it because I can't help thinking of that primal moment of rebellion every time Bart Simpson bares his unrepentant buttocks to the air. Like his forbears, Bart shows us his name on the tail of his shirt, demonstrating what Marcus calls " . . . a certain American spirit that never disappears no matter how smooth things get." Consider also that Homer's and Bart's rear ends are themselves talented entertainers that can actually do impressions.

[12] It's been pointed out that *Futurama* is to *The Simpsons* as *The Jetsons* was to *The Flintstones*. Younger readers, take note: this one's bound to show up on the S.A.T.'s. Also, be prepared for this soon-to-be-familiar job interview question: "If you had to choose between working for Mr. Slate, Mr. Spacely, or Mr. Burns, who would you work for and why? And what the devil is a 'sprocket'?"

[13] Collectors of the Future! Don't do what I have done. In the name of all that's decent, let your toys fly free! Let Buzz Lightyear buzz! Let Pikachu peek at you! Let Darth Maul maul you! Don't become what I've become, a sad miser hoarding his treasure who searches in vain for love and acceptance amongst his plastic playpals. Above all, don't let your soul's epitaph become "NRFB"!

[14] I just wanted another chance to use the phrase "unrepentant buttocks." Thank you.

Yellow Fever!

Imagine a world without them.

Imagine for a moment going on a tour of this World That Might Have Been, your host a ghostly figure who doesn't resemble Jacob Marley so much as an infamous 104 year-old animated industrialist. "Come now, you addlepated slugabed," he reprimands you, "I'm not paying you to sit there and chortle at *Captain Billy's Whiz Bang*!" Your index finger makes contact with one of his bony digits and you're off . . .

In the blink of an eye, you're whisked away to the living room of a typical American family circa 2010, observing them as they desperately search for some kind of entertainment on their High Definition Boob Tube ("Give me Uncle Miltie prancing about in assorted foundation garments," your host volunteers cheerily, "now that was entertainment!"). A few channel-surfed seconds of each program is sufficient for your purpose. It's obvious that something has gone terribly wrong. The one-note sitcoms are worse than you remember. The laugh tracks seem to have been cranked up several decibels higher. And strangest of all:

There's no prime-time animation.

It's hard to remember what television was like before we met The Simpsons ("Simpson, eh?," your host inquires, a Paleolithic light bulb going off somewhere). Their irreverence, topicality and sheer volume of jokes raised the bar for every other sitcom on the air. It was the show that broke all the rules before anyone could stop them and, because of that, The Simpsons have been a breath of fresh air since their very first appearance. Somewhere in Springfield there's Homer, eternally baffled and befuddled; Marge, Queen of the Kitchen; Bart, preteen iconoclast; Lisa, doll-loving suffragette; and Maggie, whose silence speaks volumes.

Now in its twelfth season, the show has become a television institution, an animated classic that rewards repeated viewings and whose catchphrases and characters have insinuated themselves into our everyday lives. Homer's frustrated cry of "D'oh!" and his equally jubilant "Woo Hoo!" echo daily around the world from the schoolyard to the boardroom, expressing what mere words cannot. And, in a supreme stroke of irony akin to the Grinch carving the Roast Beast, Bart Simpson himself, the supreme underachiever of the 1990s, was cho-

sen by *Time Magazine* as Cartoon Character of the Century, a selection that prompted one outraged reader to have a cow and ask for an apology!

Without their example, it's hard to imagine *Ren and Stimpy* getting their shot at the big time, not to mention *Beavis and Butthead*, *The Critic*, *King Of The Hill*, *South Park*, *The PJ's*, and *Family Guy*. And the shows keep coming: Matt Groening appears to have duplicated his *Simpsons* success with *Futurama*, while ABC premiered a cartoon sitcom based on the characters from Kevin Smith's movie *Clerks* last year. In the course of pioneering the idea of animated shows that children and adults could equally enjoy, *The Simpsons* did wonders for its own longevity. Not only has it surpassed the previous record for longest running animated program (held previously by *The Flintstones*), it is now the longest running sitcom currently on the air, period.

February 2000 marked the show's 10th anniversary, and events and collectibles were planned to mark the occasion. And not just any old collectibles: *Simpsons* characters who have never seen the light of a store shelf before have appeared, as Fox aggressively renews the licenses for the show. In short, 2000 looked poised to match those early salad days of the 1990s, when one couldn't negotiate a toy store aisle without encountering a spiky-haired head. But how did we get here, dude?

Even casual *Simpsons* fans know by now that the family's roots can be traced back to the wickedly funny weekly strip that Matt Groening began drawing in the 1970s, *Life In Hell*, a strip that Groening originally peddled from store-to-store in xerox form before it found a permanent home at the *L.A. Reader*. He continues to draw it to this very day. It was James Brooks and Sam Simon who thought it might make a nice sorbet between the sketches on the fledgling *Tracey Ullman Show*. As legend has it, Groening, not wishing to give up the rights to his characters, quickly fashioned a last-minute replacement right before a meeting, naming this new bunch after the family he grew up in. They would be as dysfunctional and socially inept as his *Hell* characters, but their problems would be, in typical sitcom fashion, family problems. *The Simpsons*, then, would simultaneously be able to parody those shows that had come before them, while taking on issues that no one had before.

After years of following the antics of the idle rich on shows like *Dallas* and *Dynasty*, the television audience was grateful for the blue collar lunacy of Springfield. In 1990, they were granted their own show and the image of Bart Simpson was suddenly inescapable. During this first flush of popularity, it decorated everything from dolls to clocks to towels to T-shirts, with kids proudly pledging allegiance to the "world's greatest underachiever." All of a sudden, putting a cartoon show on in prime time seemed like anything but a risk. Unfortunately, many shows crashed and burned attempting to duplicate the success of *The Simpsons,* while the show that started all the fuss went gamely onward, introducing new characters, hatching ever more outrageous plots, and turning out the smartest comedy writing TV had seen in ages.

The collectibles most people remember from this first wave of merchandise are the many, many Bart dolls, both plastic and plush, that lined toy aisles, as well as the other family members transformed into rubber bendies and rag dolls. Dan Dee was the manufacturer of these most common of Simpson collectibles (Jesco made the bendies), including the memorable "Talking Bart Simpson" which warned kids they were being duped! The so-called "Burger King" dolls, promotional rag dolls with plastic heads, also date from this heady time. It's literally impossible to attend any kind of garage sale without coming across one or more

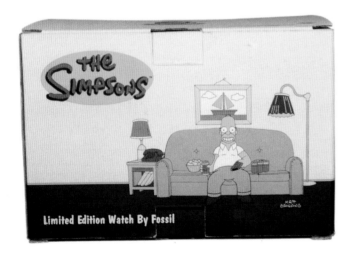

Homer Limited Edition Watch from Fossil.

well-made, they accurately reflected the show, and fans loved them. Mattel upped the ante with three large "activity" dolls of the Simpson kids, each supplied with matching toys for the doll and the kid that played with it.

Comic artist Bill Morrison (*Roswell, Little Green Man, Simpsons Comics*) was hired at the peak of the craze to help provide packaging art. He's since gone on to work on many other *Simpsons*-related projects and is currently the Art Director for *Futurama*. According to Morrison, the show's immense popularity began to work against it, and the sheer abundance of *Simpsons* toys that was starting to sit on shelves led some to think that the show, and its merchandise, had seen its day. "People became tired of it," he says,

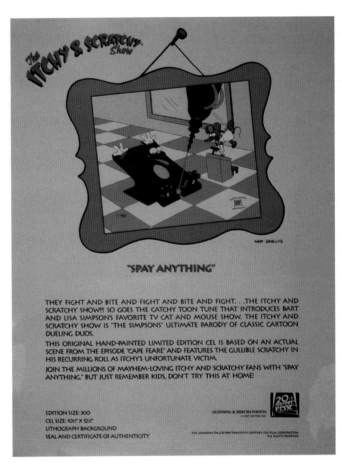

Ad for Limited Edition cel. This one would go nicely in the baby's room.

of these beauties, though, as common as they are, it's not always easy to find their cardboard accompaniments (Homer's bowling ball, Marge's purse, etc.).

It was Mattel that helped bring a little dignity to the proceedings by producing a line of *Simpsons* action figures that fans still hanker after today. It included all five Simpsons and threw in Bartman and Nelson Muntz for good measure! They had articulated body parts and came with accessories, including word balloons for each figure that would fit neatly into the tops of their heads. As if that weren't enough, the *Sofa and Boob Tube* set featured a couch (with ejector seat) and TV set (with interchangeable pictures). They were

"and, as a result, companies were reluctant to make any more. There were a lot of things that we were still interested in doing, though."

Another line of Mattel toys that was considered, and which would have included spring-loaded Family Car and Nuclear Van break-apart vehicles, never got past the prototype stage. An Otto doll was similarly designed and abandoned. "I remember a motorized barbeque grill that was going to be made for Homer," says Morrison, who also recalls a talking Grampa Simpson doll that never saw the light of day. "There was going to be a Ninja Bart and a Baseball Bart with a cap and bat," according to the artist.

Clearly, though, the blush was off the rose. Soon, the same stores that had been loaded with Bart buttons and banners were consigning them to their clearance aisle or not carrying them at all.

Gradually, however, new and improved *Simpsons* memorabilia began to appear. An official publication called *Simpsons Illustrated* provided interviews, behind-the-scene glimpses of the show, and the first ever use of The Simpsons in comic strip format. It would eventually lead to an all-comics test issue of *Simpsons Comics and Stories* that would in turn launch the Bongo Comics Group, an imprint that published *Simpsons*-related comic books. Nintendo began to issue *Simpsons* video games featuring the family. Two new sets of trading cards from Skybox, each with a plethora of desirable chase cards, were met with acclaim.

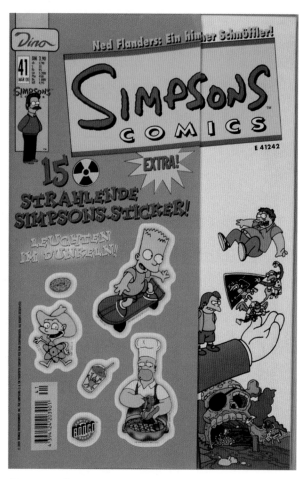

Simpsons Comics #41 from Germany with glow-in-the-dark stickers.

The Internet, of course, was also helping to change things. Fans now had access to online auctions that allowed them to bid on collectibles from around the world. To their astonishment, many found that quality Simpsons collectibles were still being produced regularly in the U.K., Australia, and elsewhere. Not to mention the new gen-

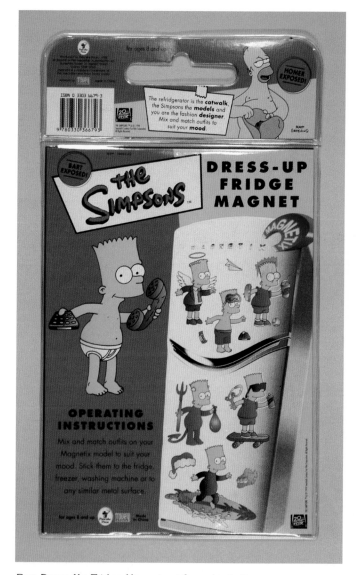

Bart Dress-Up Fridge Magnet set from Australia.

eration of fans who hadn't seen the original memorabilia during its first go-round and who now felt the need to catch up. One website that came to their rescue was Bill LaRue's *Collecting Simpsons!*, an online guide to everything Simpson that featured regular updates on the latest paraphernalia. Sparked by his rediscovery of the Burger King dolls, the bug bit hard. "It wasn't so old that it was hard to find things, but there were still enough rarities to provide the thrill of the hunt," says LaRue. His website took his hobby to the next logical step by attempting to catalog everything he'd managed to find. Even LaRue admits, though, "you can't have everything."

There was a general sense among fans during the late 1990s that, even though there wasn't as much stuff being produced, what was out there now was generally better-done and practically begged to be collected. With the release of an official guide to every episode of the show that left no minutiae unrevealed (including helpful

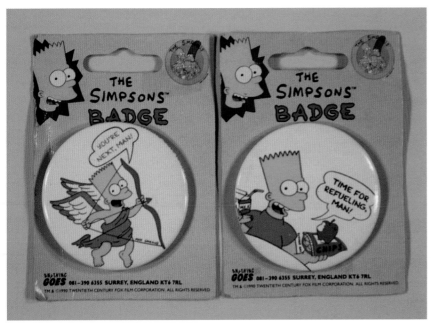

Bart pins from U.K.

are here to stay." It's hard to doubt him, as the show continues to go in new and unexpected directions while remaining true to its original and anarchic spirit.

"Spirit?" your host asks inquiringly. "Why, I haven't been able to countenance anything in the way of potables since Aubrey Beardsley tricked me into drinking that glass of absinthe! I later dreamt I was being chased by great dumb beasts with scarcely a hair upon their heads, wielding strange, almost donut-like, devices of destruction. What do you suppose it meant?" You shrug and suggest that it might be a good time to go home. "Poppycock!" your companion replies, "Why, the night's positively fetal! They tell me I'm quite the terror at Old Maid when my blood count's been regulated, what do you say?"

lists of every time Homer has uttered his immortal "D'oh!"), a CD soundtrack of the show's original songs, and the long awaited release of episodes on videotape, a corner was turned and the show's profile seemed to return to the high gloss it had known in the early '90s.

If LaRue's site helped bring some long overdue respectability to the hobby, *The Unauthorized Guide To The Simpsons Collectibles* (by this author and published by Schiffer Books in 1998) helped to consolidate it. Now there was a price guide that collectors could hold in their hands as proof that they weren't alone. Hundreds of color photos of collectibles helped chart th dars have returned to stores. The year 2000 was earmarked to celebrate the show's 10th anniversary and, as we commence the next 1,000 years of Simpsonmania, there's been no let up of events, including the show's receiving a star on the Hollywood Walk Of Fame, live appearances and trivia contests, and the first ever official *Simpsons Fanfest*.

On top of that, the U.S. has finally rejoined the rest of the free world in the production of Simpson toys. As you read this, the *World Of Springfield* continues to expand with new interactive figures of Springfield's denizens that talk when used with special playsets (including a Kwik-E-Mart!), while larger dolls of the family can actually argue with each other, Furby-style. Sequels to the official show guide and soundtrack arrived in 1999 and Simpsons Pez dispensers have finally arrived as well, along with an official Homer Simpson Charcoal Grill! "There's a whole generation of kids who have never known a world without the Simpsons," Bill Morrison concludes. "I think people are starting to realize that, like Mickey Mouse, the Simpsons

Chapter One: Dolls/Figures

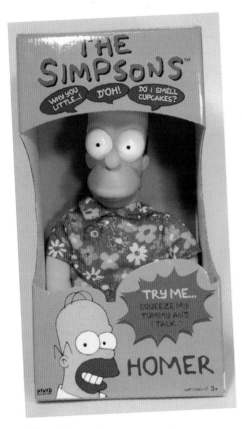

Talking Homer Simpson doll from Vivid
Imaginations, U.K. $25-30.

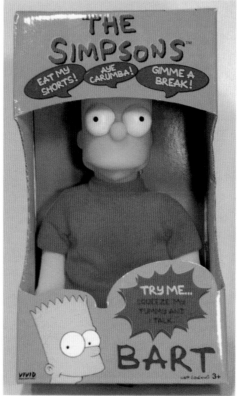

Talking Bart Simpson doll. Vivid
Imaginations, U.K. $25-30.

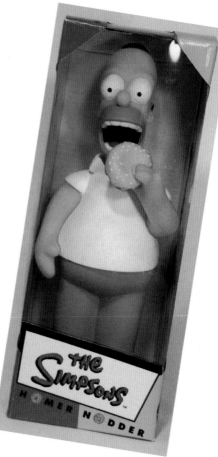

Homer Simpson Nodder from
Custom Accessories, U.K. $12-15.

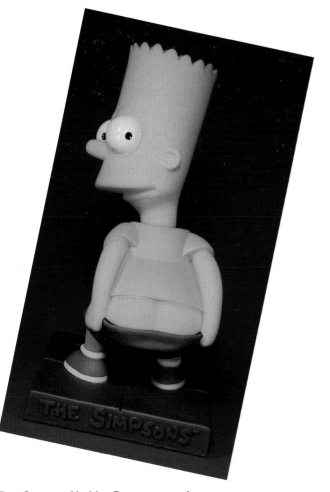

Bart Simpson Nodder. Bart assumes the position. I see no repentance in his steely gaze, do you? Custom Accessories, U.K. $12-15.

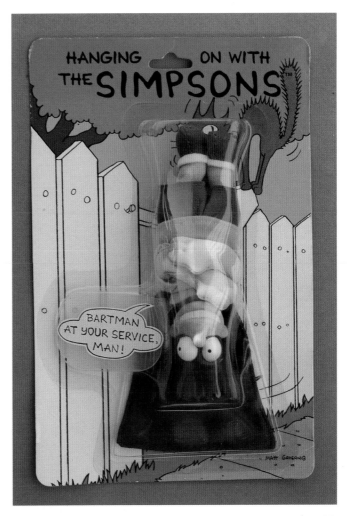

Bartman Clip-On from Pony, U.K. $15-20.

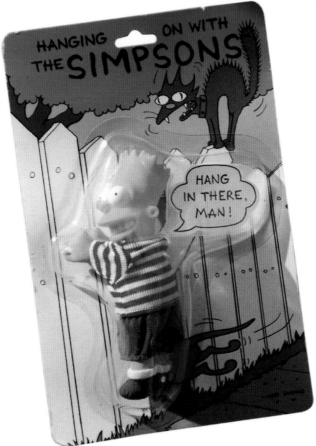

Bart Simpson Clip-On. Pony, U.K. $15-20.

Marge Simpson figurine, carded.
Miniland, Spain. $30-40.

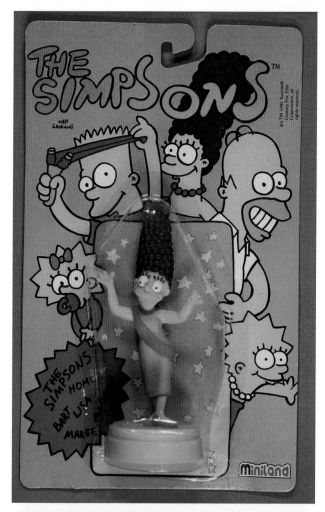

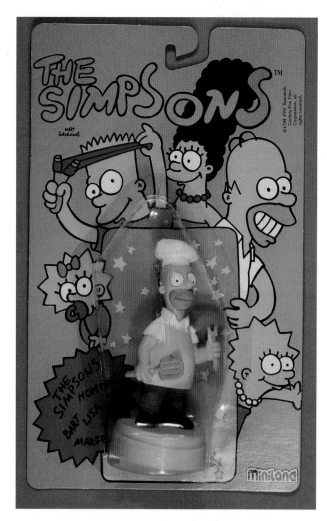

Homer Simpson figurine from Miniland, Spain. Carded.
These early figures from Spain are fairly uncommon,
although variants of them (uncarded, without the base or as
keychains) are easier to find. Note the almost bootleg-style
design on the card. It's interesting, too, that the character
designs seem to come straight from the Spanish "Los
Simpson" card game that appeared in my first book.
$30-40.

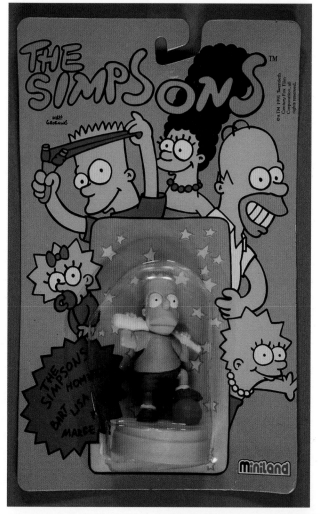

Bart Simpson figurine with bat and
ball, carded. Miniland, Spain. $30-40.

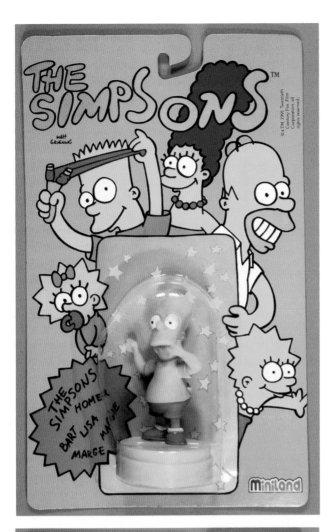

Bart Simpson figurine, carded.
Miniland, Spain. $30-40.

Maggie Simpson figurine, carded.
Miniland, Spain. $30-40.

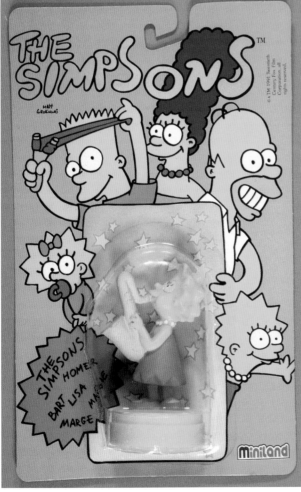

Lisa Simpson figurine, carded.
Miniland, Spain. $30-40.

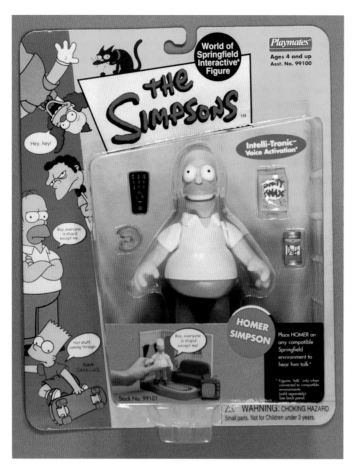

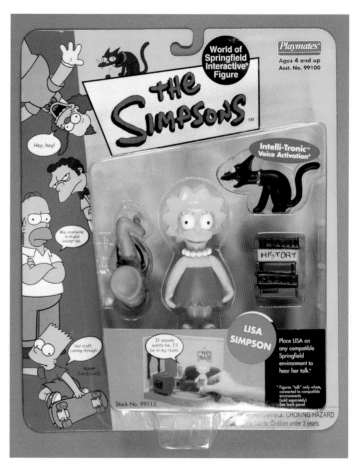

Homer Simpson Intelli-Tronic Interactive Figure from Playmates. With remote control, donut, Duff can, and Salty Snax. $5-8.

Bart Simpson Intelli-Tronic Interactive Figure. With paint can, slingshot, skateboard, Santa's Little Helper. Playmates. $5-8.

Lisa Simpson Intelli-Tronic Interactive Figure. With books, saxophone, Snowball II. Playmates. $5-8.

Grampa Simpson Intelli-Tronic Interactive Figure. With newspaper and magnifying glass. Playmates. $5-8.

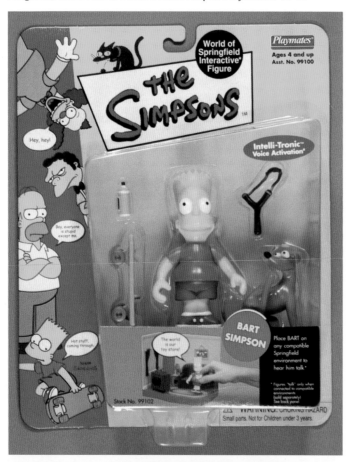

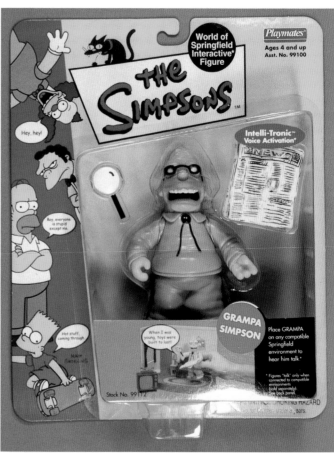

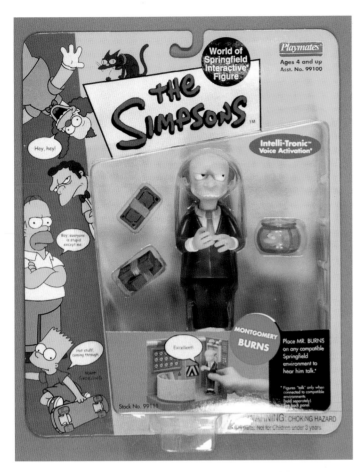

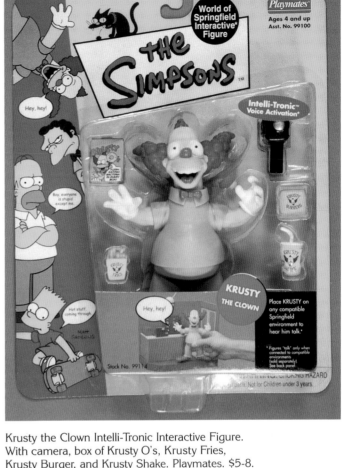

Montgomery Burns Intelli-Tronic Interactive Figure. With money and Blinky in fishbowl. Playmates. $5-8.

Krusty the Clown Intelli-Tronic Interactive Figure. With camera, box of Krusty O's, Krusty Fries, Krusty Burger, and Krusty Shake. Playmates. $5-8.

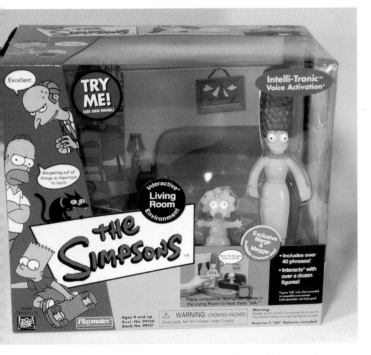

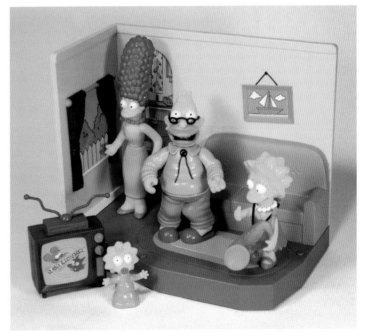

Living Room Interactive Environment with exclusive Marge and Maggie figures. Plug in any "interactive" Simpsons figure and hear a familiar phrase that fits the location. Playmates. $20-25.

Grampa pays a visit. You know, back in my day, we didn't have any fancy "interactive environments." We drew faces on wooden spools and danced them around a shoebox, giving rise to the popular expression, "There's no spool like an old spool."

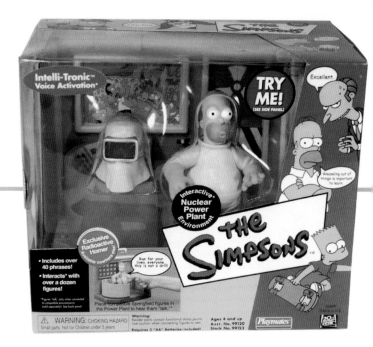

Nuclear Power Plant Interactive Environment with exclusive Radioactive Homer figure. Playmates. $20-25.

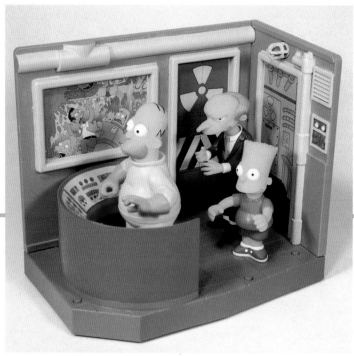

Homer giddily anticipates the anarchic results of pressing yet another unfamiliar button while Bart does his famous impression of The Great Garloo.

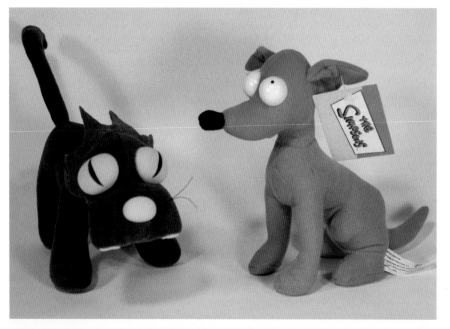

Snowball II and Santa's Little Helper "beanie" dolls from Giftware Int'l., U.K. Giftware had to scribble out the word "beanie" on the tag after complaints from another manufacturer of beanies, baby. $8-12 each.

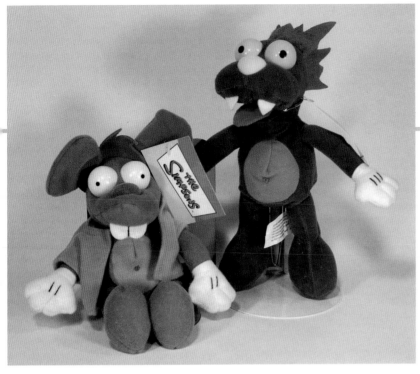

Itchy and Scratchy "beanie" dolls. Giftware, U.K. $8-12 each.

Blinky the 3-Eyed Fish "beanie" doll. Giftware, U.K. $8-12.

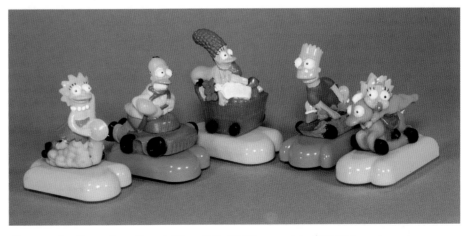

Simpson family set from Burger King, U.K. $6-10 separately, $30-50 for set.

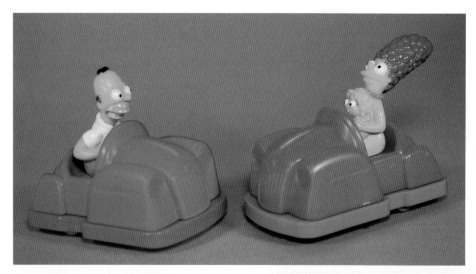

Homer and Marge/Maggie cars from Quick Restaurants, Belgium. Look, if she's old enough to shoot Mr. Burns, she's old enough to drive a car. $6-8.

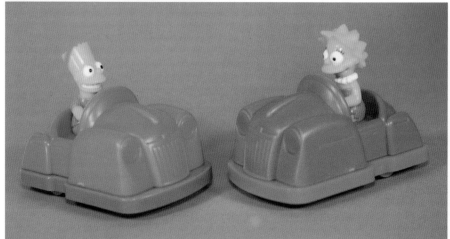

Bart and Lisa Simpson cars. Sparks always fly when these two titans of the bumper cars face off! Quick Restaurants, Belgium. $6-8.

Bulgy-eyed Bart Simpson figure from Burger King, U.K. $6-8.

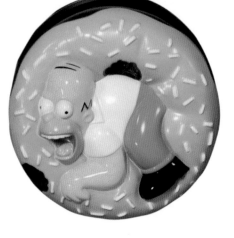

Homer's Rolling Donut. Burger King, U.K. $6-8.

Left:
Wind-up Maggie Simpson figure. Burger King, U.K. $6-8.

Marge and Snowball II figure. Burger King, U.K. $6-8.

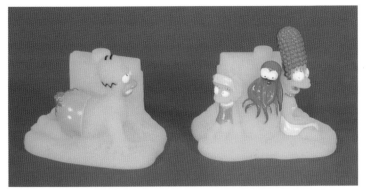

Homer and Marge/Lisa squirters from Kentucky Fried Chicken, Australia. When you collected all four pieces, you were rewarded with a scene of the family building a sandcastle. $6-8.

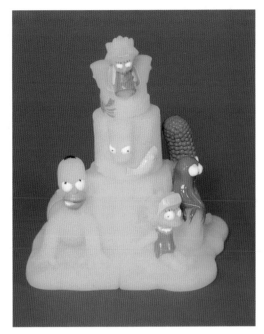

The set.

Right:
Maggie and Bart squirters. KFC, Australia. $6-8.

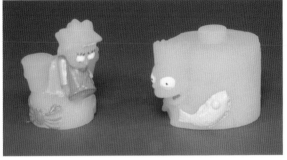

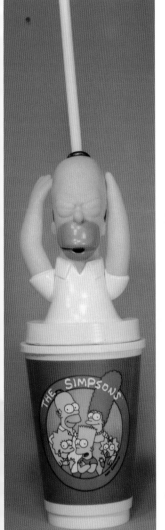

Homer Simpson Drink Topper from Kentucky Fried Chicken, Australia. This is the only Homer figure I can think of that actually catches him in mid-"D'oh!" $8-12.

Marge Simpson Drink Topper. KFC, Australia. $8-12.

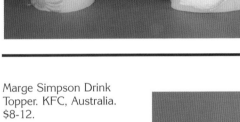

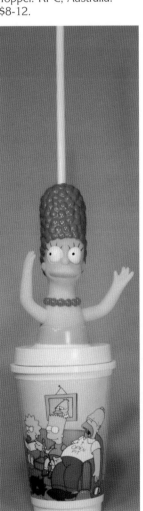

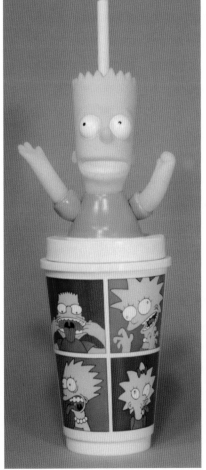

Bart Simpson Drink Topper. KFC, Australia. $8-12.

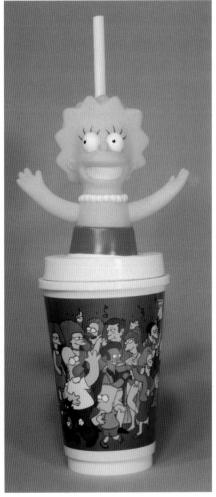

Lisa Simpson Drink Topper. KFC, Australia. $8-12.

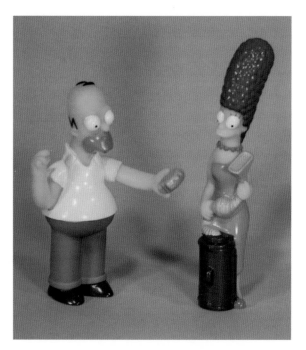

Homer and Marge Simpson figures from Burger King, U.K. This wonderful set tied in to 2000's Global Fanfest promotion and featured characters who had never been issued as figures before (see below). A classic Homer pose, but must Marge always be paired with a vacuum? Besides Homer, I mean. $6-8.

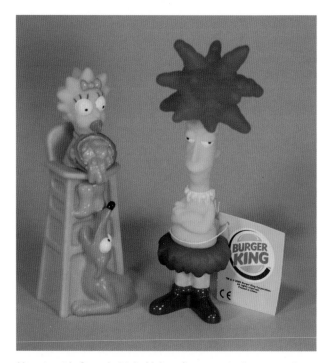

Maggie with Santa's Little Helper figure and a long-overdue Sideshow Bob. Burger King, U.K. $6-8.

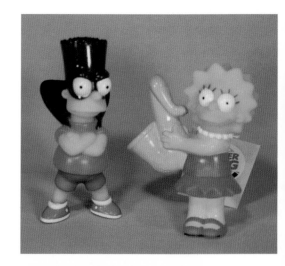

Bartman and Lisa Simpson figures. Burger King, U.K. $6-8.

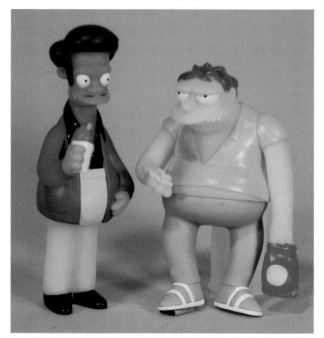

Apu Nahasapeemapetilon (complete with Squishee!) and Barney Gumble figures. Burger King, U.K. $6-8.

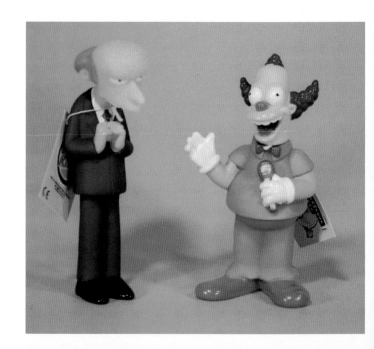

Mr. Burns and Krusty figures. Burger King, U.K. $6-8.

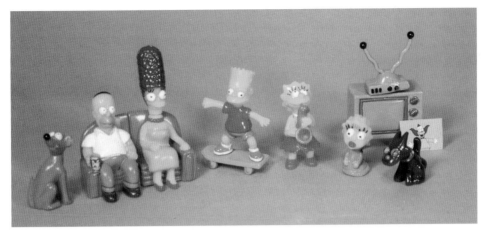

Simpsons family set from Dolcerie Veneziane, Italy. Note the Krusty sticker for the TV screen. This set is also unusual in that the figures are made out of hard plastic. $20-25.

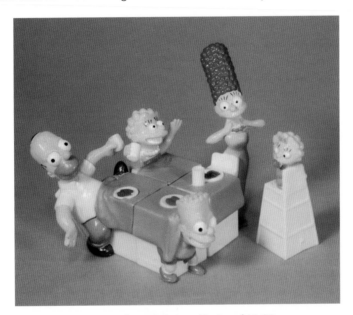

Simpsons Indoors set from Sabritas, Mexico. $15-20.

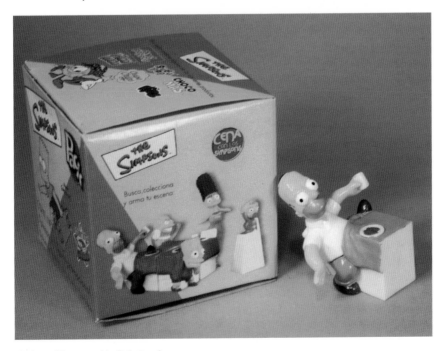

Indoor Homer with Sabritas box.

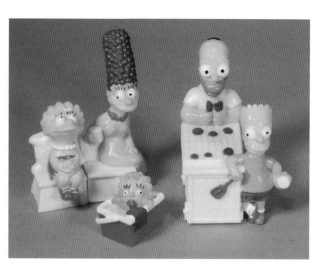

Simpsons Outdoors set. Sabritas, Mexico. $15-20.

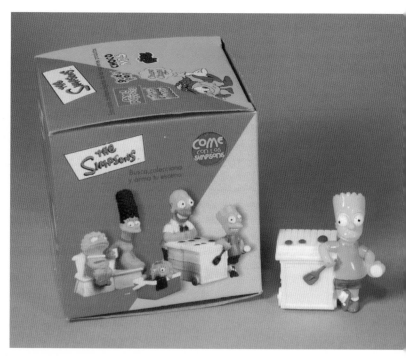

Outdoor Bart with Sabritas box.

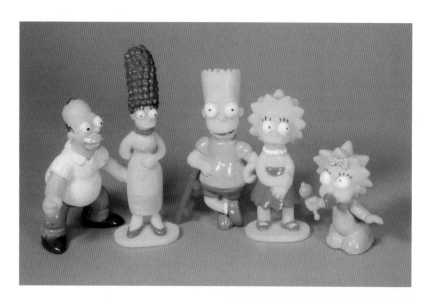

We were a little confused about these figures last time around. Here's what it looks like now: This Simpsons family set seems to come from Germany, no manufacturer indicated. However, they've also shown up . . .

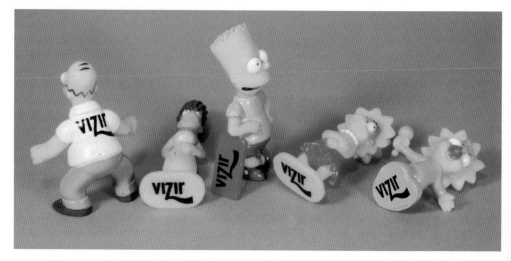

. . . with the logo from French detergent "Vizir" emblazoned on them. Regular set, $25-30, "Vizir" variants, $35-40.

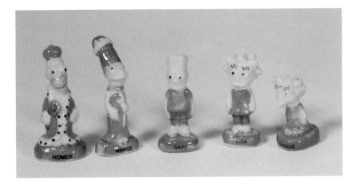

These tiny figures from Belgium are about an inch tall. Homer, Marge, Bart, Lisa, Maggie. Homer and Marge's wardrobe seems to have been borrowed from the Simpsons chess set.

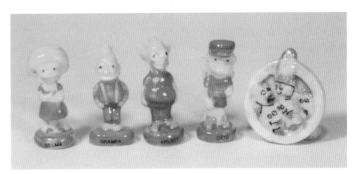

Selma, Grampa, Krusty, Otto, Family cameo. Full 10-piece set, $30-$40.

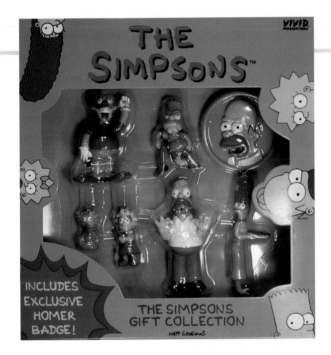

The Simpsons Gift Collection, featuring Homer, Marge, Bart, Lisa, Maggie, Krusty, and Homer badge. Vivid Imaginations, U.K. $15-20.

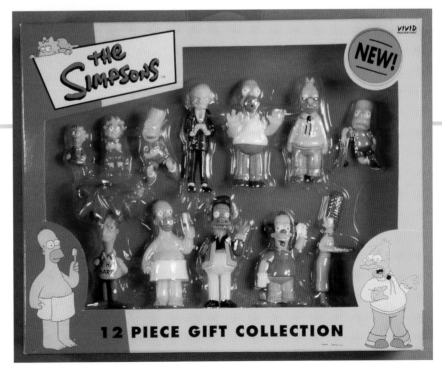

This 12-piece Simpsons Gift Collection included the six figures from the previous release (minus the Homer badge), and added Bathtowel Homer, Laughing Bart, Grampa Simpson, Mr. Burns, Apu, and Sideshow Bob. $25-30.

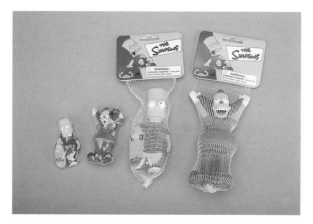

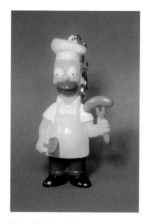

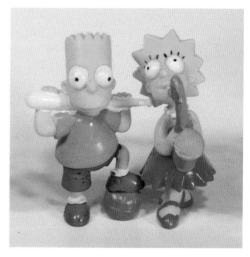

Bart and Krusty "Squeezies" and "Squeezie" keychains from Alpi International, Ltd. Homer also available. $4-6 each.

Bar-B-Que Homer keychain from Miniland, Spain. $5-8.

Baseball Bart and Lisa Simpson figures. Miniland, Spain. $5-8.

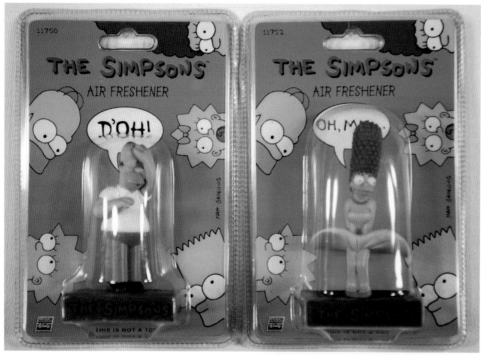

Homer and Marge Simpson Air Fresheners from Custom Accessories, U.K. $6-8.

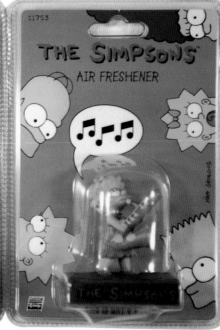

Bart and Lisa Simpson Air Fresheners. Custom Accessories, U.K. $6-8.

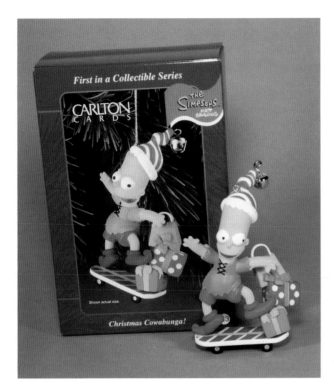

First in a series of collectible Simpsons Christmas ornaments from Carlton, "Christmas Cowabunga!" shows an elfin Bart preparing to spread holiday mayhem. $15-20.

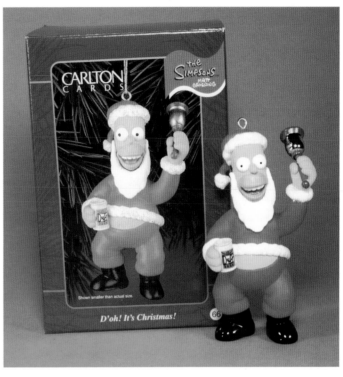

"D'oh! It's Christmas!" is the second in the series and features a jolly St. Homer who's had a little too much holiday spirit. Carlton. $15-20.

Simpsons pencil sharpeners from Feber, Spain. And yes, they were licensed. Someday all cartoon characters will look like this. $10-$15 each.

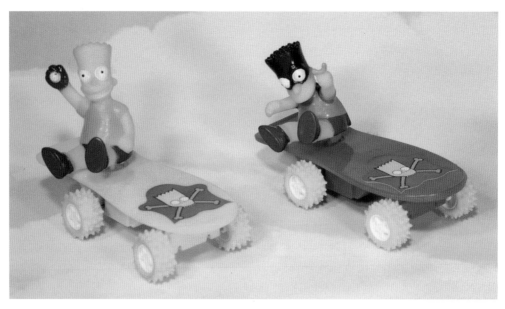

Bart Simpson and Bartman skateboard toys, no manufacturer indicated. $6-8.

This unlicensed figurine is something of a mystery, perhaps with good reason. No manufacturer indicated. $20-30.

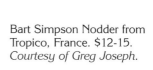

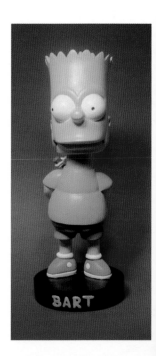

Homer and Bart figurine
from Boots, U.K. $8-10.
Courtesy of Greg Joseph.

Homer and Marge Bar-B-Que
figurine. Boots, U.K. $8-10 each.
Courtesy of Greg Joseph.

Bart Simpson Nodder from
Tropico, France. $12-15.
Courtesy of Greg Joseph.

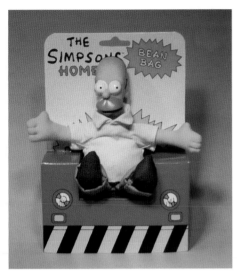

Homer Beanie, er . . . Bean Bag doll from Jemini, France. See *The Simpsons*™ *Collectibles* for more in the series. $8-12. *Courtesy of Greg Joseph.*

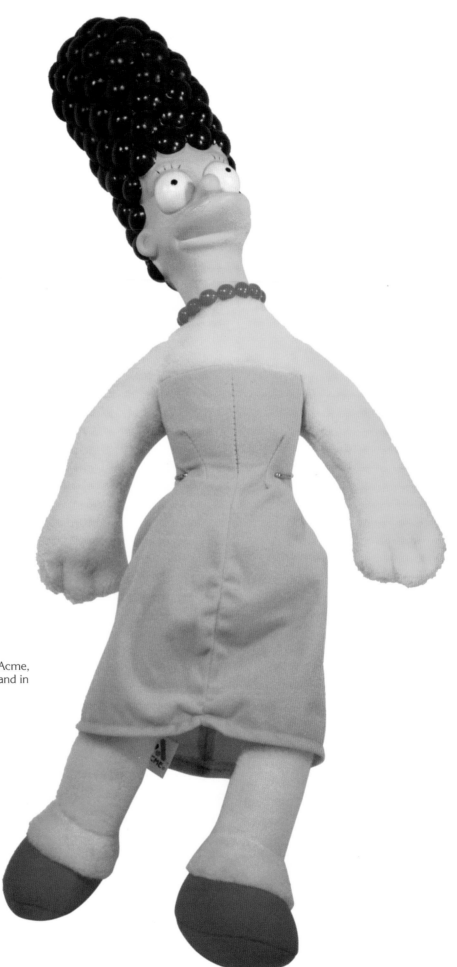

Large Marge Simpson plush from Acme, found back in the day at carnivals and in arcades. $50-70.

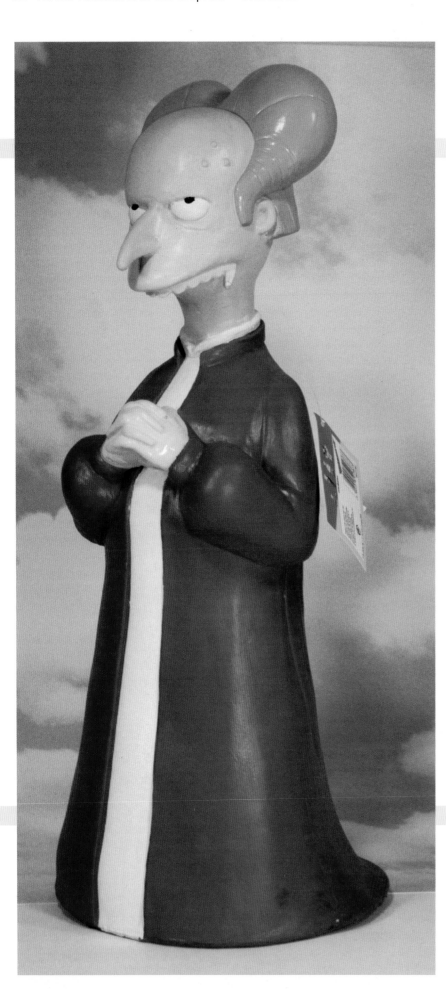

Release the checkbook! How could you possibly live without this? From A La Carte in Germany comes this 19-inch tall foam rubber Mr. Burns, done up as Dracula from the Francis Ford Coppola version. *Futurama* fans desperate for product can also pretend it's Mom of Mom's Robot Oil fame. $35-45.

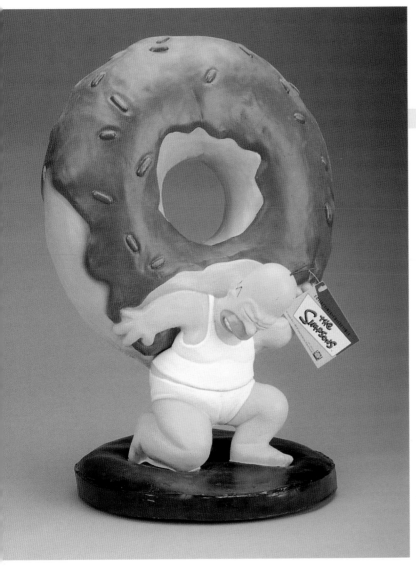

Also from A La Carte comes this Homer Atlas supporting a giant donut on his back. It's the sprinkles that make it heavy. Other A La Carte figures include a Krusty and a Maggie. Best Collectible Ever! $35-45.

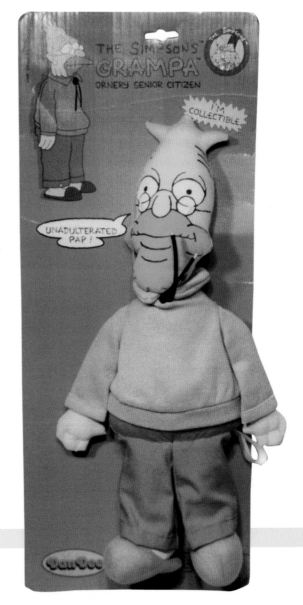

Here comes Grampa, "Ornery Senior Citizen." This Dan Dee rag doll was never produced and is extremely uncommon. You know, in my day, we didn't have prototypes! We just stuck an apple on a stick and pretended it was Herbert Hoover. $150 and up. *Courtesy of Greg Joseph.*

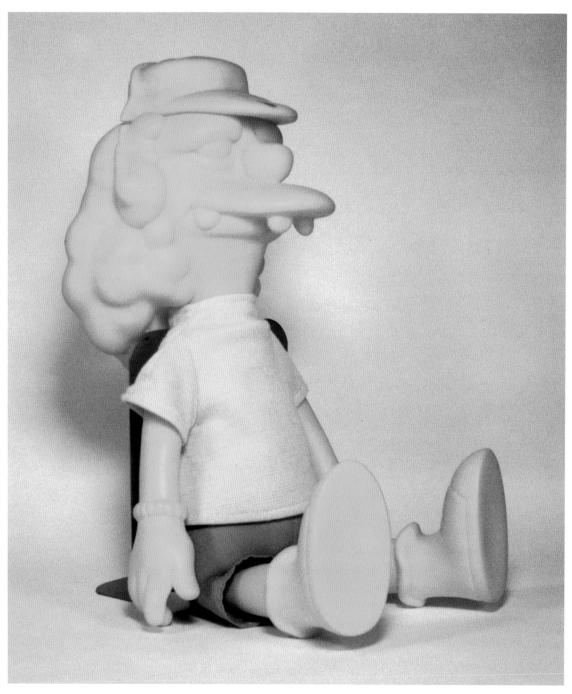

The Otto Man Who Never Was. As you can see, Dan Dee also had plans for an Otto doll similar to their large talking Bart, with plastic head, arms, and legs. Unfortunately, it never made it to toy store shelves. Now, for the first time, you can enjoy examining Otto's distinctive slacker anatomy at your leisure. $300 and up.

Left:
Of course, it's fun to think about . . .

Right:
. . . the accessories Otto could have had . . .

. . . especially that jacket . . .

. . . with the funny smell.

Chapter Two: Homer's Bathroom
(Soaps, Shampoos, Beauty Supplies)

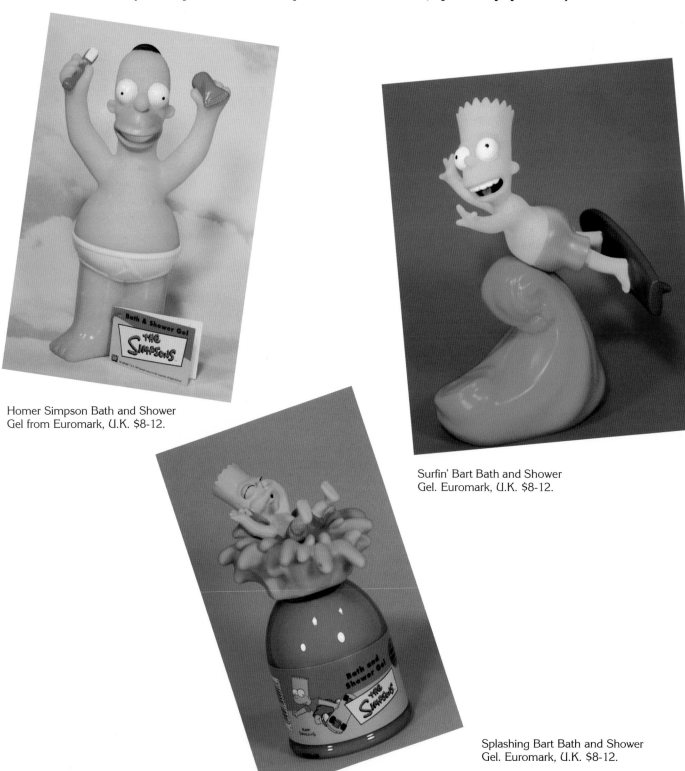

Homer Simpson Bath and Shower
Gel from Euromark, U.K. $8-12.

Surfin' Bart Bath and Shower
Gel. Euromark, U.K. $8-12.

Splashing Bart Bath and Shower
Gel. Euromark, U.K. $8-12.

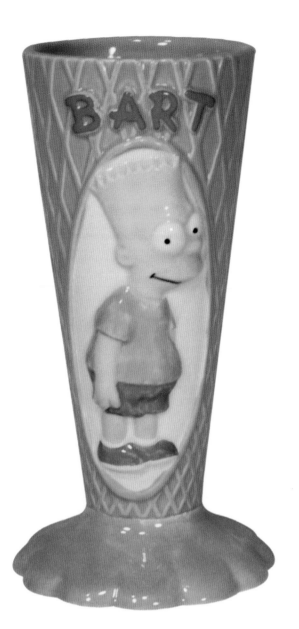

Homer and Bart Simpson Salt and Pepper shakers. Tropico, France. $25-30.

Bart Simpson ice cream dish. Tropico, France. $25-30.

Bart Simpson ashtray from Demons & Merveilles, France. $8-12 each.

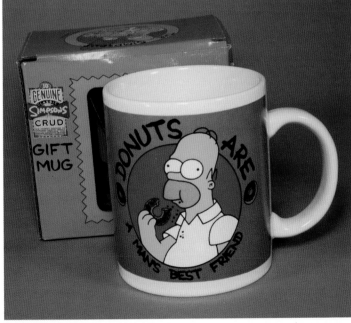

This Homer Gift Mug is "Genuine Classy Simpsons Crud" celebrating "10 Miserable Years," according to the box. U.K. $10-15.

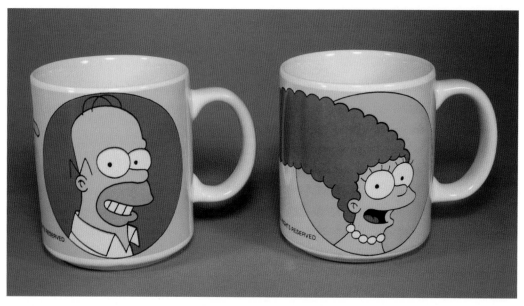

Homer and Marge Simpson mugs from Tropico, France. $10-15 each.

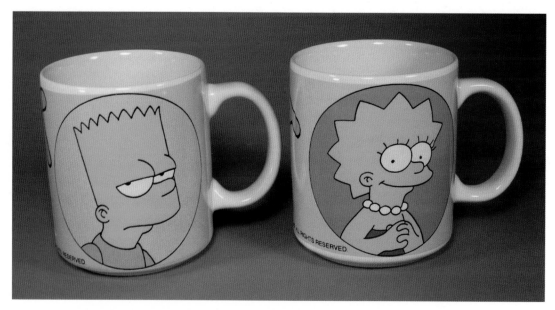

Bart and Lisa Simpson mugs. Tropico, France. $10-15 each.

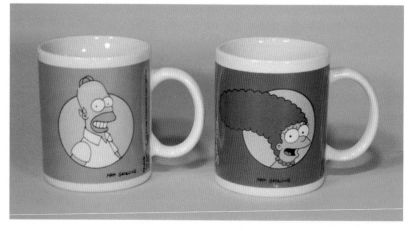

Homer and Marge Simpson mugs from Quick Restaurants, Belgium. These were a promotional offer available only at the restaurant. $15-20 each.

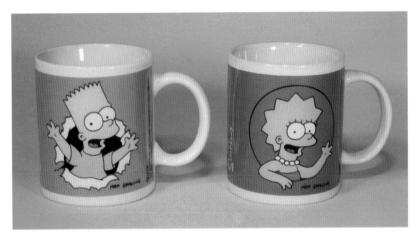

Bart and Lisa Simpson mugs. Quick Restaurants, Belgium. $15-20 each.

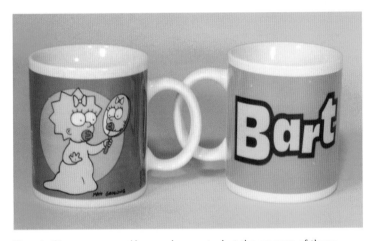

Maggie Simpson mug. Also, a glance at what the reverse of these mugs looked like. Quick Restaurants, Belgium. $15-20.

Bart and Homer mugs from Rodelco, U.K. $8-12. *Courtesy of Greg Joseph.*

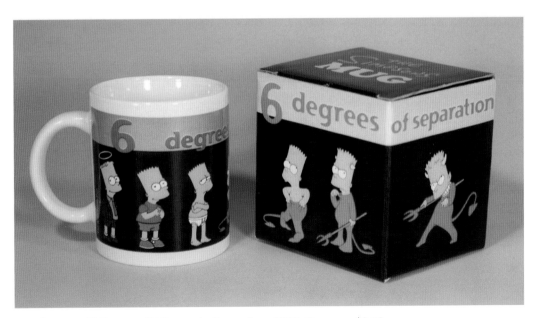

Bart Simpson "6 Degrees Of Separation" mug from CTM, Germany. $8-12.

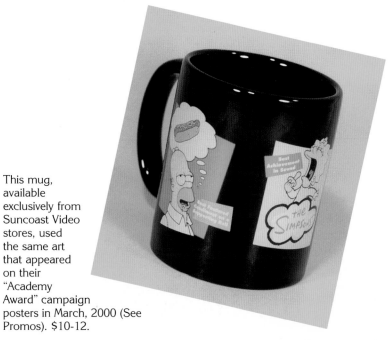

This mug, available exclusively from Suncoast Video stores, used the same art that appeared on their "Academy Award" campaign posters in March, 2000 (See Promos). $10-12.

Bart Simpson cup from Gaffney Int'l, U.K. $6-8.

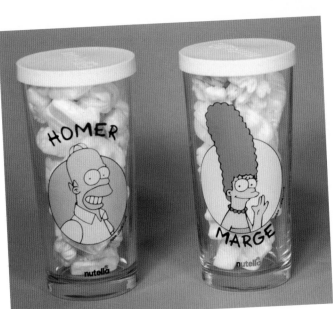

Nutella Hazlenut Spread has offered two sets of collectible Simpsons glasses in Australia, consisting of eight glasses each. Here's the Homer and Marge glasses from Set #1. Ferrero. $8-12 each.

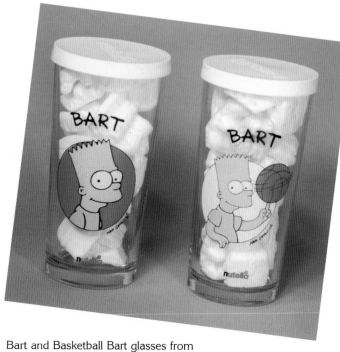

Bart and Basketball Bart glasses from Nutella Set #1. $8-12 each.

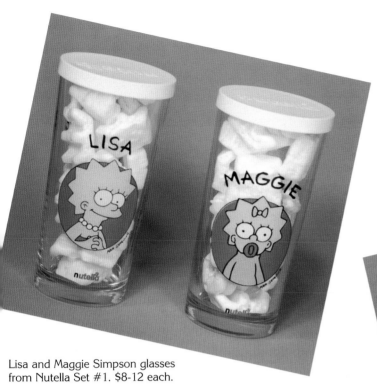

Lisa and Maggie Simpson glasses
from Nutella Set #1. $8-12 each.

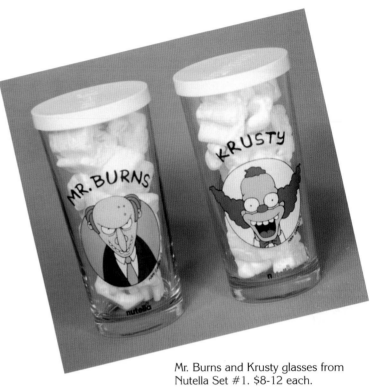

Mr. Burns and Krusty glasses from
Nutella Set #1. $8-12 each.

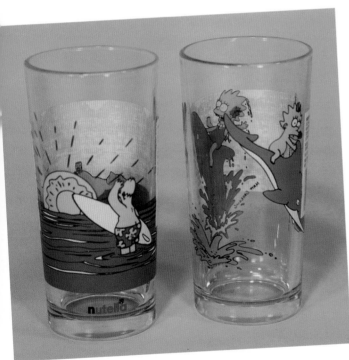

Donut Sunset and Lisa and Maggie glasses
from Nutella Set #2. $8-12 each.

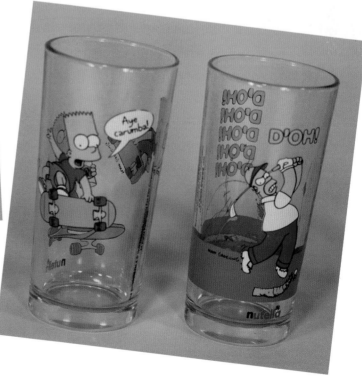

Bart and Homer Simpson glasses from Nutella Set #2. $8-12 each.

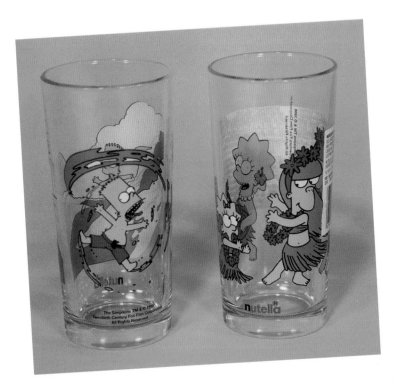

Surfin' Bart and Hula Girls glasses from Nutella Set #2. $8-12 each.

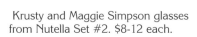

Krusty and Maggie Simpson glasses from Nutella Set #2. $8-12 each.

Also from Australia comes this set of four glasses, available exclusively from Hungry Jack's Restaurants. From the look of the logo, they appear to be the Aussie equivalent of Burger King. TV Time and See-Saw glasses, $8-12 each.

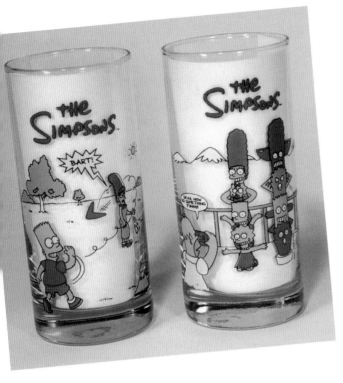

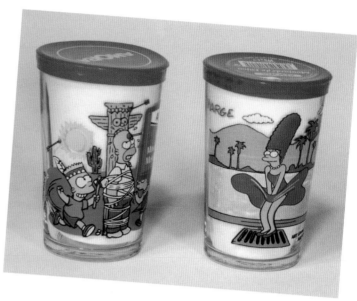

Boomerang Bart and Vacation Time glasses from Hungry Jack's, Australia. $8-12 each.

Amora Mustard jars from Belgium. There were six different Simpsons jars available. The Simpsons logo appears on the glass as "The Simpsons" or "Les Simpsons," depending on point of origin. $8-12 each.

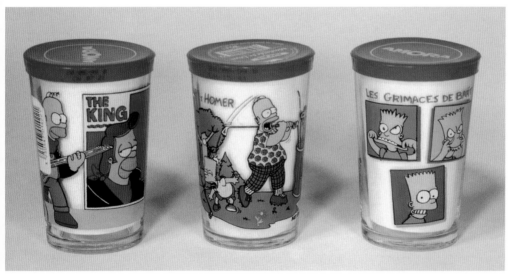

Amora Mustard jars, Belgium. $8-12.

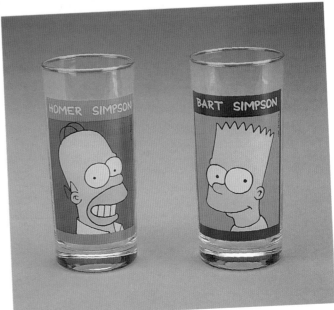

Homer and Bart promo glasses from Roda/Resi Margarine, Belgium. $10-15 each.

Bart Simpson glass, manufacturer unknown. $5-8. *Courtesy of Greg Joseph.*

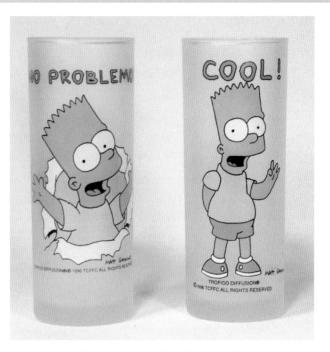

Bart Simpson frosted glasses from Tropico, France. "No Problemo!" and "Cool!" $10-15 each.

"Cool, Man" tall glass from Australia. $10-15.

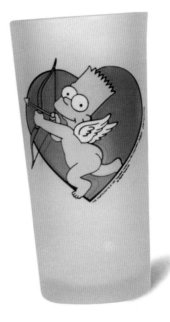

Cupid Bart tall glass from Australia. $10-15.

Bart Simpson tall glass from Tropico, France. $10-15.

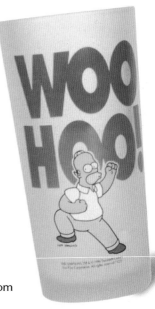

"Woo Hoo!" tall glass from Australia. $10-15.

Homer Simpson tall glass. Australia. $10-15.

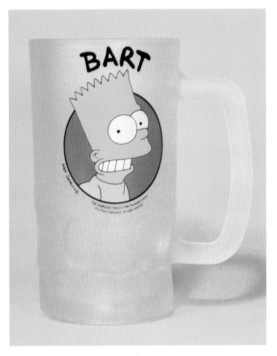

Bart Simpson glass mug from Tropico, France. $15-20.

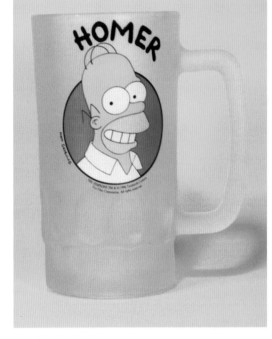

Homer Simpson glass mug. Tropico, France. $15-20.

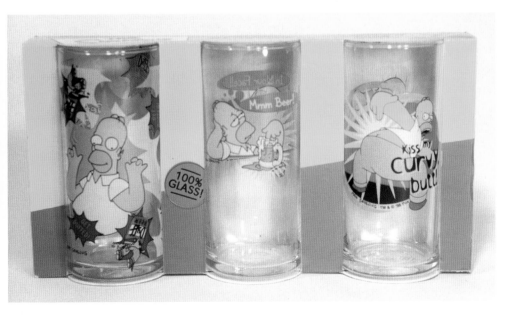

Homer Simpson glasses, set of three, from Crystal Craft, U.K. $15-20.

Bart Simpson glass, Australia. $8-12.

Homer Simpson glass, Australia. $8-12.

Homer Simpson glass,
Australia. $8-12.

Bart badge scotch glass,
Australia. $8-12.

Barney scotch glass,
Australia. $8-12.

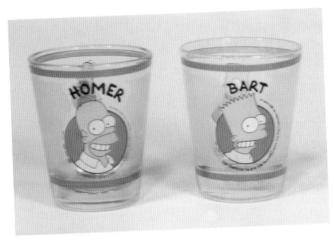

Homer and Bart shot glasses, Australia. Use these too often and everything will look as blurry as this picture. $6-10 each.

Moe and Barney shot glasses, Australia. All too appropriate. Pickled eggs extra. $6-10 each.

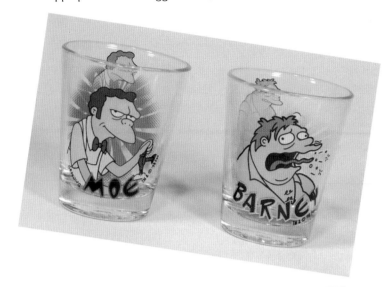

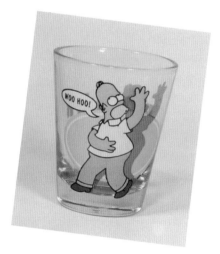

Homer Simpson shot glass, Australia. $6-10.

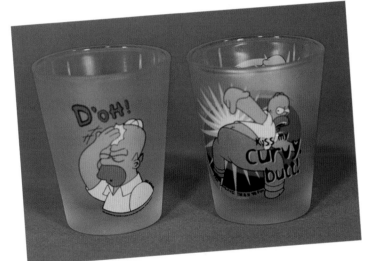

Homer Simpson shot glasses, Australia. $6-10 each.

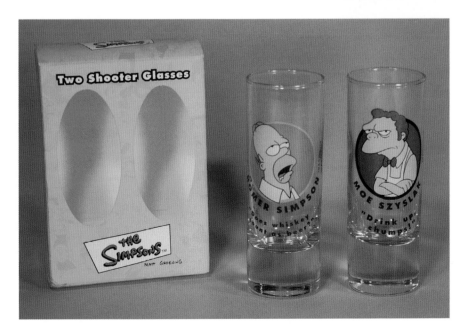

Homer Simpson and Moe Szyslak shooter glasses from Signature. $8-12.

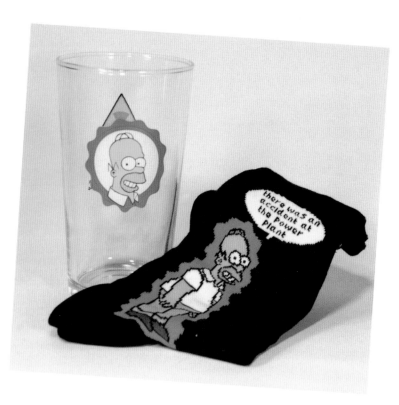

Radioactive Homer Socks and Glass set from BHS, U.K. $10-15.

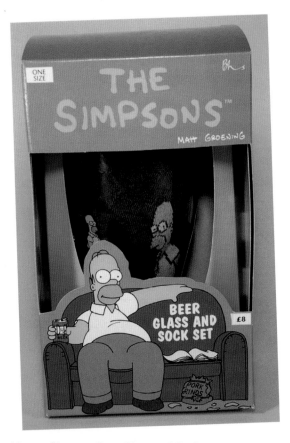

Homer Simpson Beer Glass and Socks set. BHS, U.K. $10-15.

Krusty the Clown straw from Hunter Leisure, Australia. $6-10.

Homer Simpson BBQ Gourmet Apron from Innovo, Inc. There were three different styles available. $15-20.

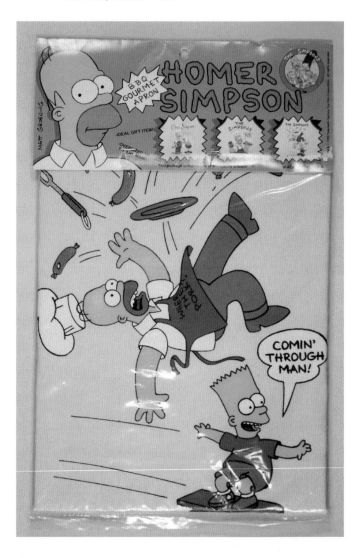

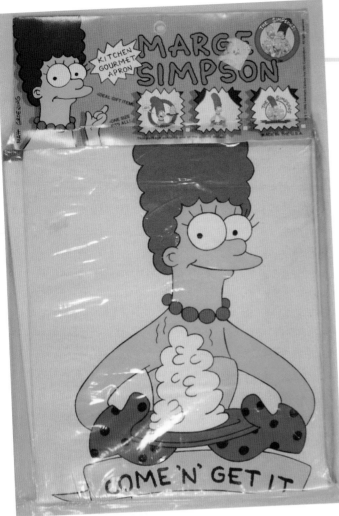

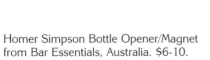

Marge Simpson Kitchen Gourmet Apron. Innovo, Inc.
One of three different styles. $15-20.

Homer Simpson Bottle Opener/Magnet
from Bar Essentials, Australia. $6-10.

Duff Beer Bottle Opener/Magnet. Bar
Essentials, Australia. $6-10.

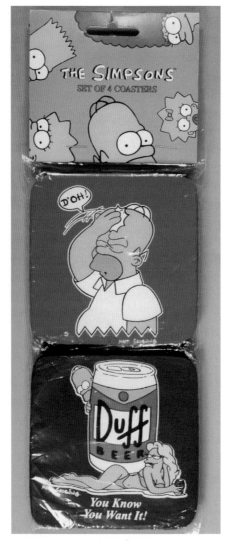

Simpsons Coasters, set of four.
Bar Essentials, Australia. $8-12.

. . . and the other side.

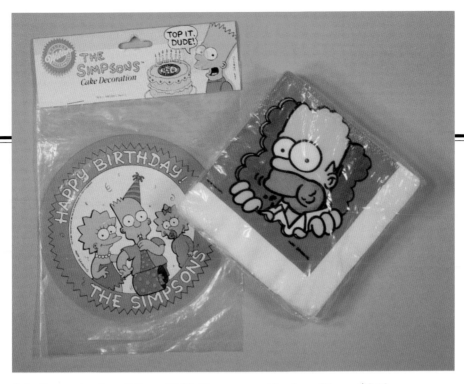

Cake Decoration from Wilton, $6-10. Beverage napkins from Gibson, $6-10.

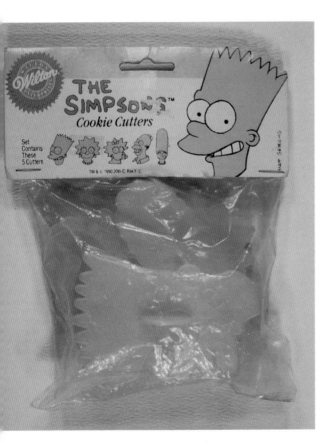

Simpsons Cookie Cutters from Wilton, $12-15.

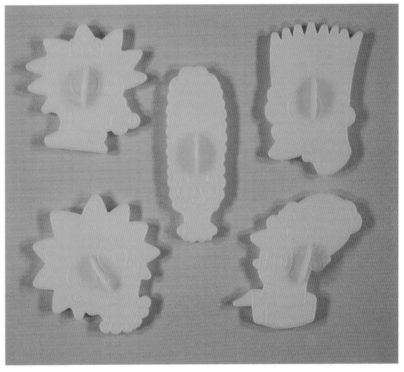

The cutters revealed.

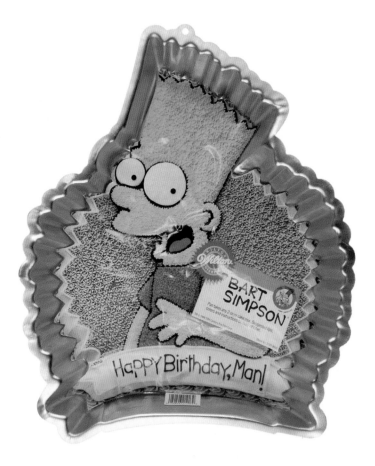

Bart Simpson Cake Pan from Wilton. $25-30.

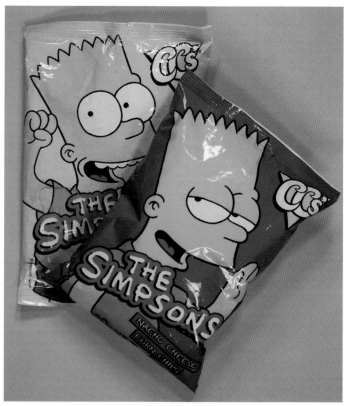

CC's Corn Chips Bart bags from Smith's
Snackfood, Australia. $8-12 each.

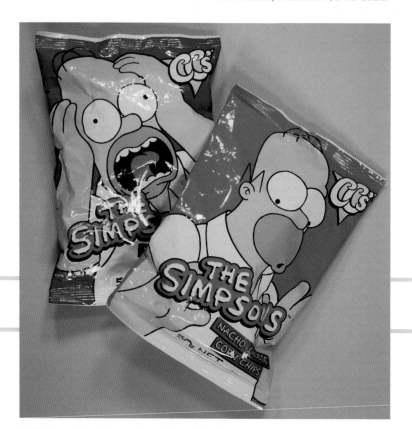

CC's Corn Chips Homer bags from Smith's
Snackfood, Australia. $8-12 each.

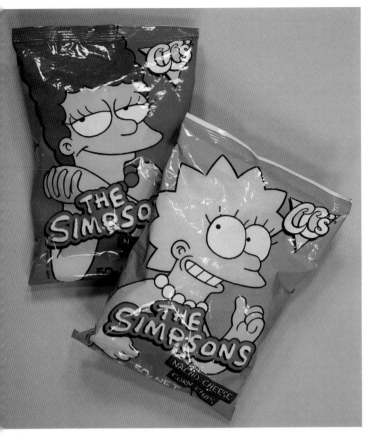

CC's Corn Chips Marge and Lisa bags from
Smith's Snackfood, Australia. $8-12 each.

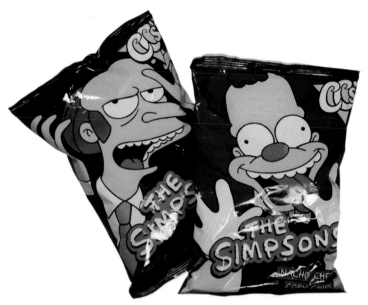

CC's Corn Chips Mr. Burns and Krusty bags
from Smith's Snackfood, Australia. $8-12 each.

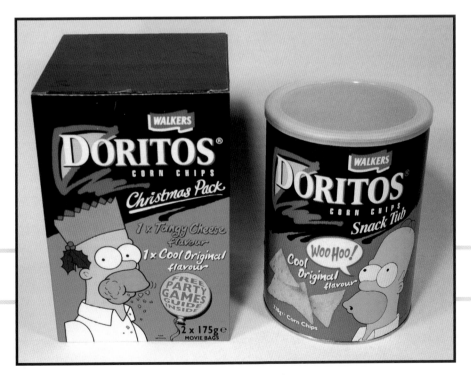

Doritos Corn Chips, box and tub, from Walkers, U.K. $8-12 each.

Simpsons Biscuits from Danone,
Belgium. $10-12.

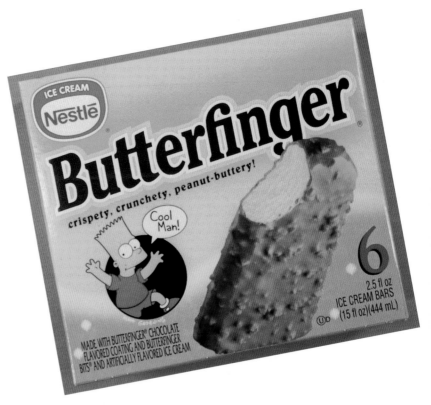

Butterfinger box from Nestle. $5-8.

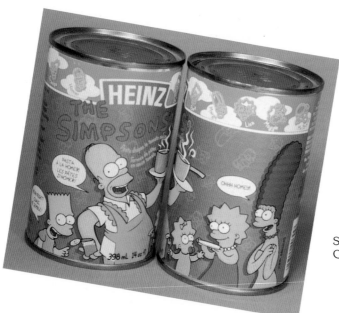

Simpsons Pasta Shapes from Heinz,
Canada. $6-10.

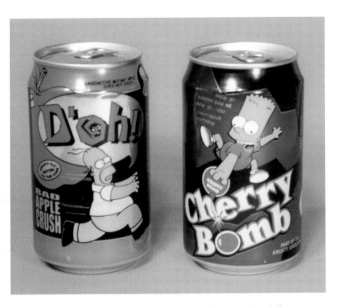

Homer's "Bad Apple Crush" and Bart's "Cherry Bomb" drinks from Hall and Woodhouse, U.K. $6-10 each.

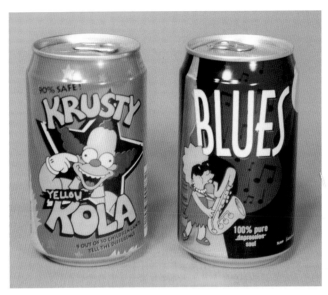

"Krusty Kola" and Lisa's "Blues" drinks. Hall and Woodhouse, U.K. $6-10 each.

Iced Tea from Puck, Belgium. $6-10.

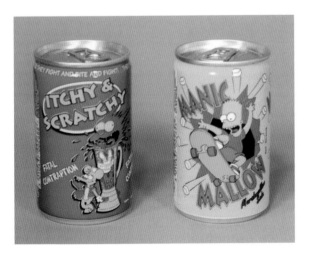

"Itchy and Scratchy" and "Manic Mallow" drinks. Hall and Woodhouse, U.K. $6-10 each.

Orange Juice from Puck, Belgium. $6-10.

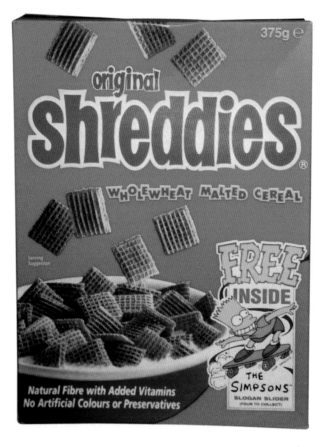

"Shreddies" cereal from Partners, U.K.
$6-10. *Courtesy of Greg Joseph.*

. . . and on the flip side. *Courtesy of Greg Joseph.*

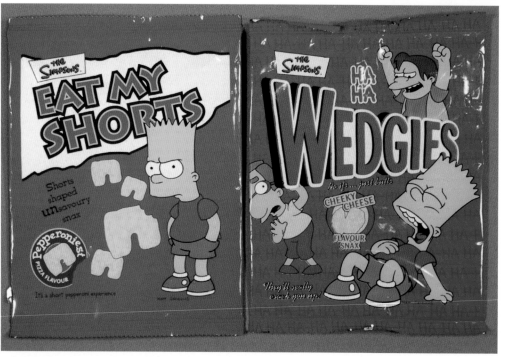

Ladies and gentlemen, this is what makes it all worthwhile. Here we have "Eat My Shorts" pizza-flavored snacks, along with "Wedgies" cheese-flavored snacks. I suppose there's a chance that something could come along that would bring me as much delight as this simple red foil bag, but I doubt it. Notice that the Laughing Bart on the "Wedgies" bag is the obvious model for the laughing figure in the 12-piece Gift Collection from Vivid Imaginations. Character Snackfoods, U.K. $3-6 each.

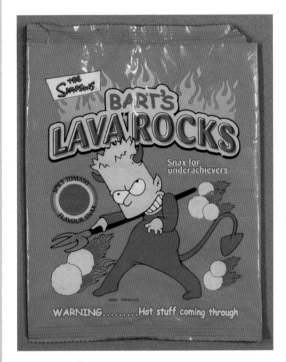

Bart's Lava Rocks snack.
Character Snackfoods, U.K. $3-6.

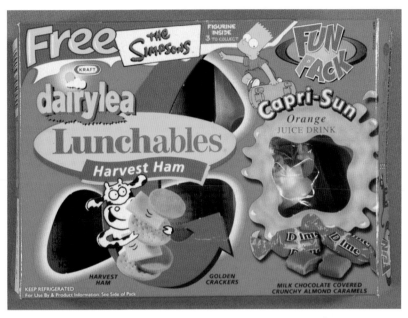

This U.K. "Lunchables Fun Pack" from Kraft came
with either a Homer, a Marge, or a Bart figure. $4-6.

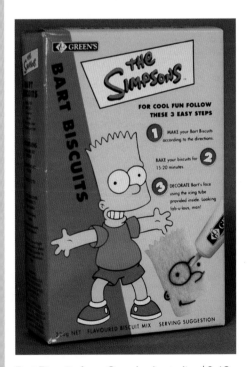

Bart Biscuits from Green's, Australia. $8-12.

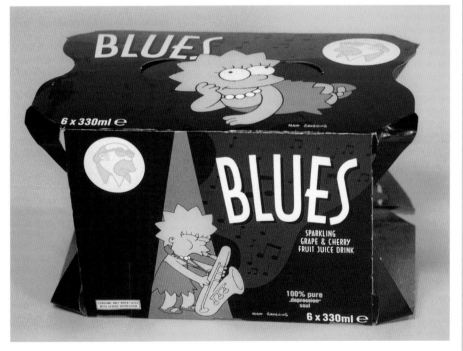

Lisa's "Blues" drink six-pack box. Hall and Woodhouse, U.K. $4-6.

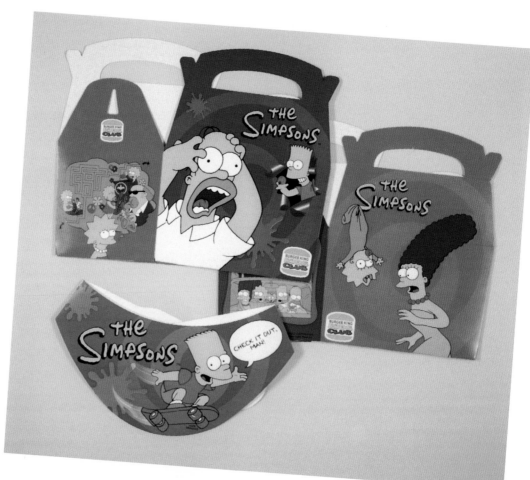

Burger King "Kids Club" meal box from 1998, U.K. $3-6.

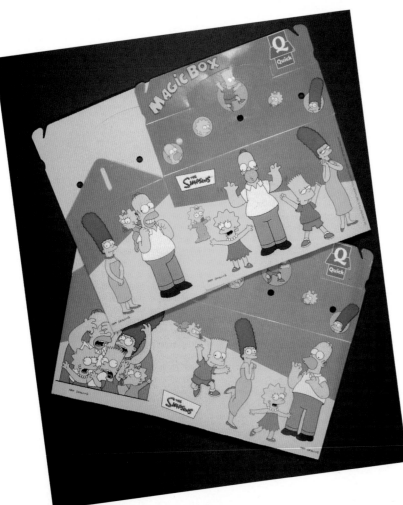

Quick "Magic Box" meal box from Belgium. $5-8.

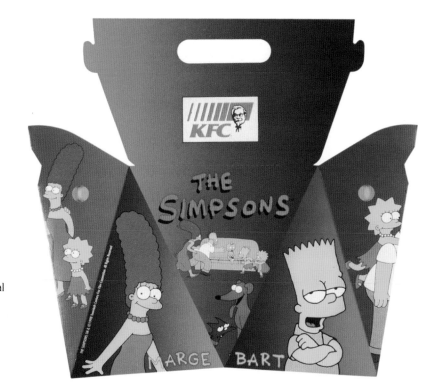

Kentucky Fried Chicken meal box from Australia. $5-8.

Party box from Quela, Mexico. $3-6.

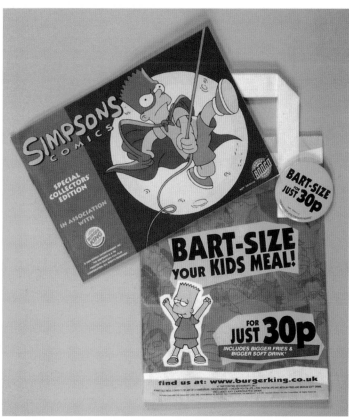

From the Burger King U.K. promotion, 2000: Meal bag, $1-3, "Bart-Size" badge, $5-8, and special limited Simpsons comic, $3-6.

Simpsons Chocolate Bars from Kinnerton, U.K. $6-10.

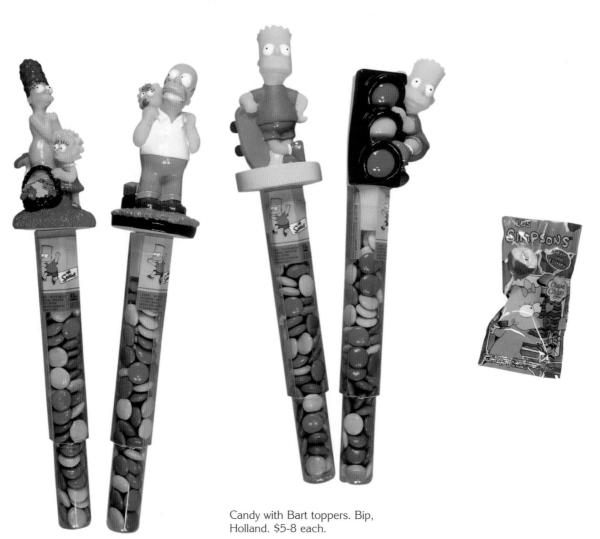

Candy with Bart toppers. Bip,
Holland. $5-8 each.

Candy with Homer/Maggie
topper and Marge/Lisa topper
from Bip, Holland. $5-8 each.

Los Simpsons lollipops from
Chupa Chups, Mexico. $8-12.

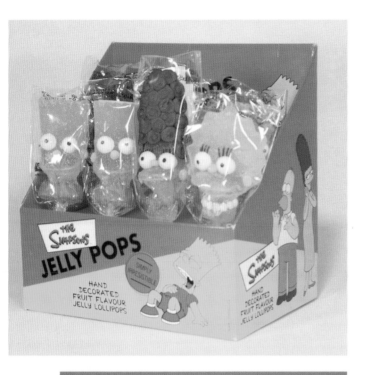

Simpsons Jelly Pops from Mike and
Jack, Australia. $20-25 for box.

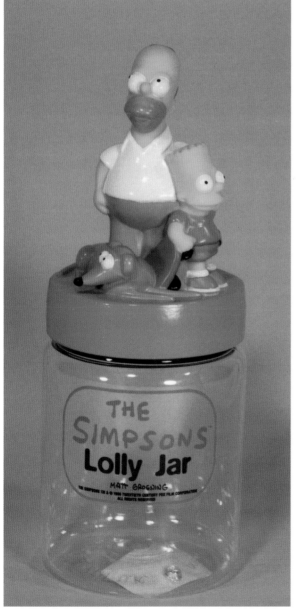

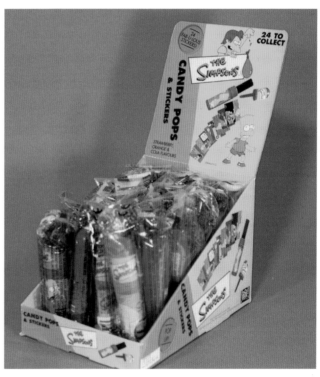

Candy Pops and stickers from JNH
Toys, Australia. $20-25 for box.

Simpsons Lolly Jar from Andus
Noble Blyth, U.K. $8-12.

Bart candy tin. Kinnerton, U.K. $5-8.

Homer candy tin from
Kinnerton, U.K. $5-8.

Lisa candy tin. Kinnerton, U.K. $5-8.

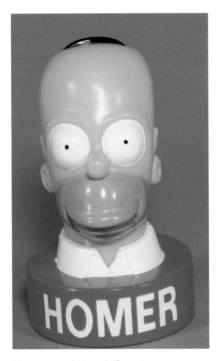

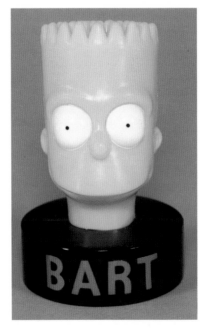

Bart candy head. Sweet Ring
Imports, U.K. $5-8.

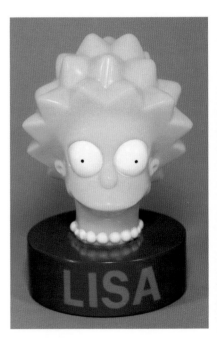

Homer candy head, Sweet
Ring Imports, U.K. $5-8.

Lisa candy head. Sweet Ring
Imports, U.K. $5-8.

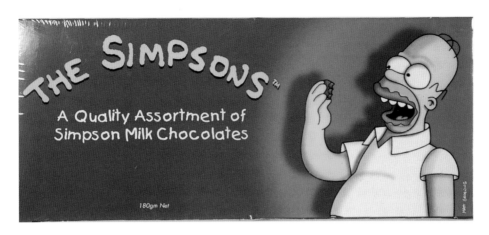

Simpsons Chocolates from Confection Concepts, Australia. $10-12.

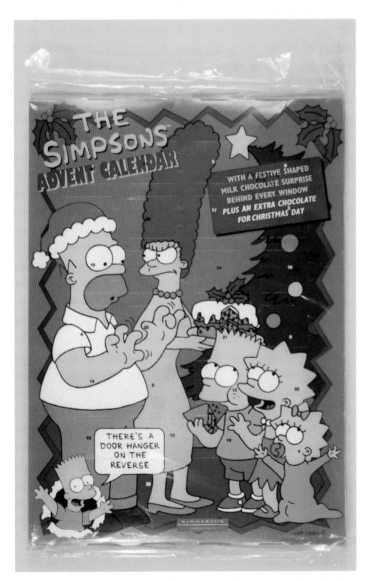

Simpsons Chocolate Advent Calendar from Kinnerton, U.K. $8-10.

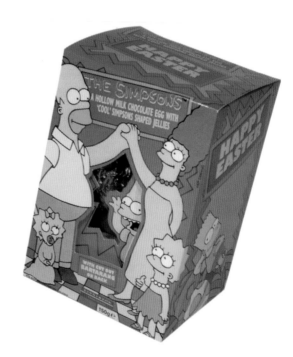

Simpsons Chocolate Egg and Jellies set. Kinnerton, U.K. $6-10.

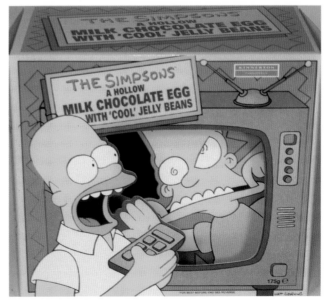

Simpsons Chocolate Egg and Jelly Bean set. Kinnerton, U.K. $8-12.

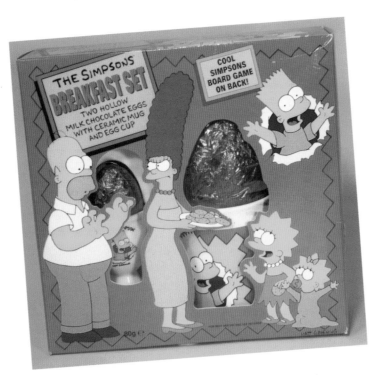

Simpsons Breakfast set, with ceramic mug, egg cup, and chocolate eggs. Kinnerton, U.K. $15-20.

Homer Chocolate Egg from Waikato Valley Chocolates, Australia. $6-10.

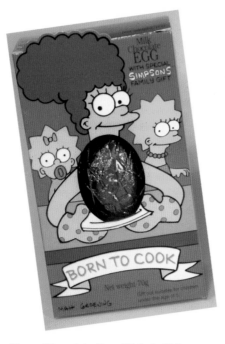

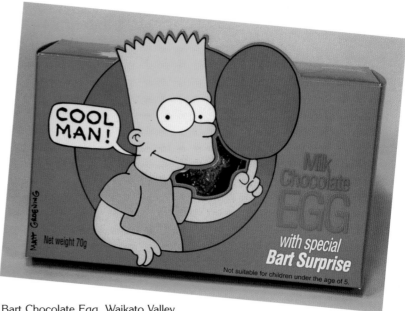

Bart Chocolate Egg. Waikato Valley Chocolates, Australia. $6-10.

Marge Chocolate Egg. Waikato Valley Chocolates, Australia. $6-10.

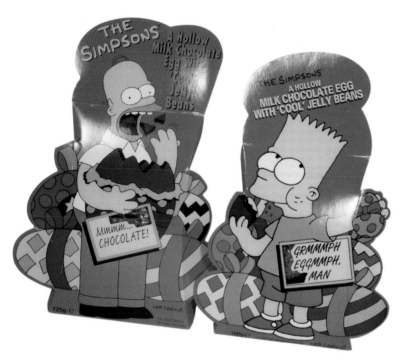

Homer and Bart Chocolate Egg and Jelly Bean sets. Kinnerton, U.K. $8-12.

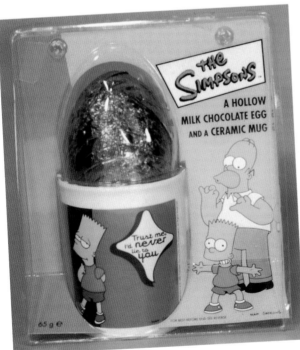

Chocolate Egg and Ceramic Mug set. Kinnerton, U.K. $15-18.

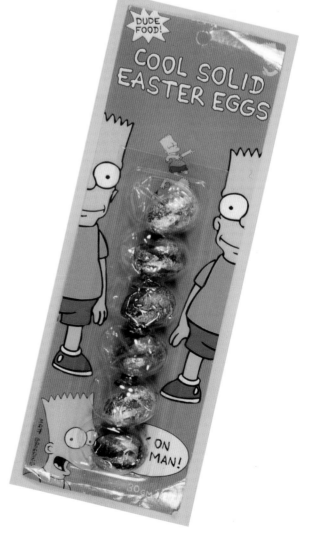

Cool Solid Easter Eggs from Waikato Valley Chocolates, Australia. $5-8.

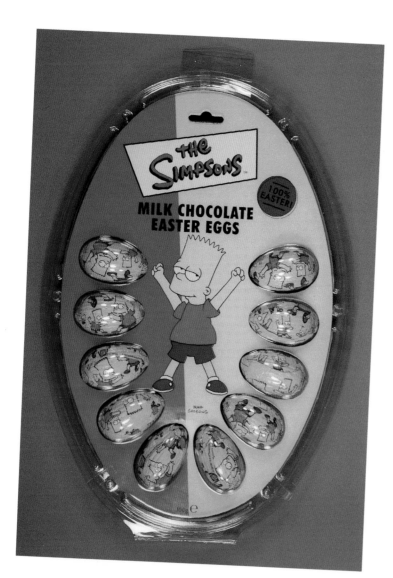

Milk Chocolate Easter Eggs from Bon Bon Buddies, Australia. $8-12.

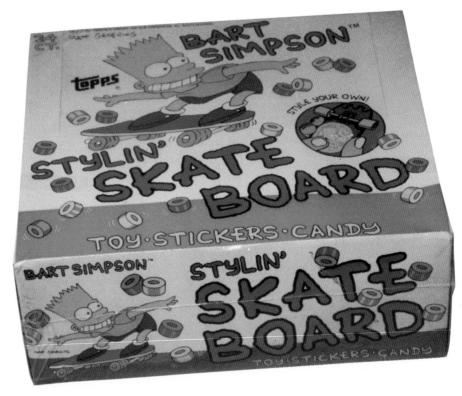

Bart Simpson Stylin' Skateboard candy from Topps, U.K. These toy skateboards came with candy and stickers. $30-40 for box. *Courtesy of Greg Joseph.*

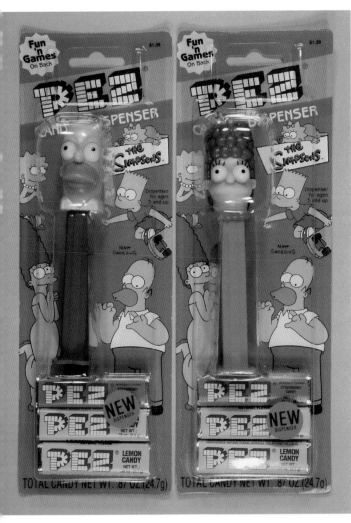

At last! The long-overdue set of Simpsons Pez dispensers finally materialized in 2000, with all five family members available in bags or carded. This is the only way you'll ever see Homer give up a piece of candy. Homer and Marge dispensers, carded, $2-4 each.

Bart and Lisa Simpson Pez dispensers (Maggie not shown), carded. $2-4 each.

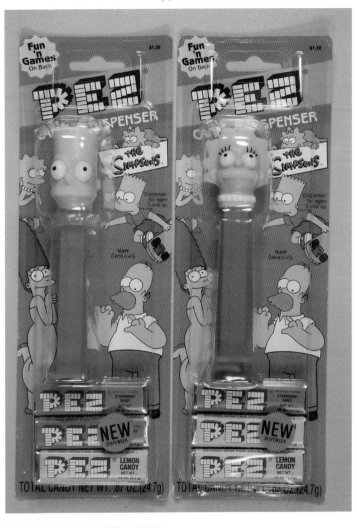

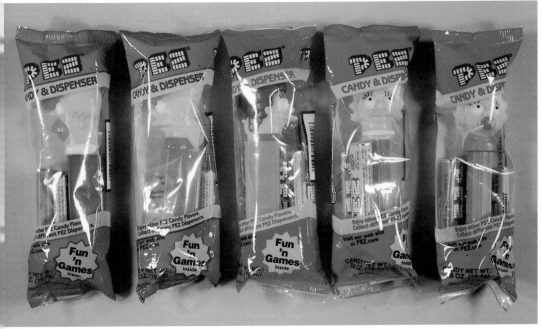

All five Simpsons Pez dispensers, bagged, $2-4 each.

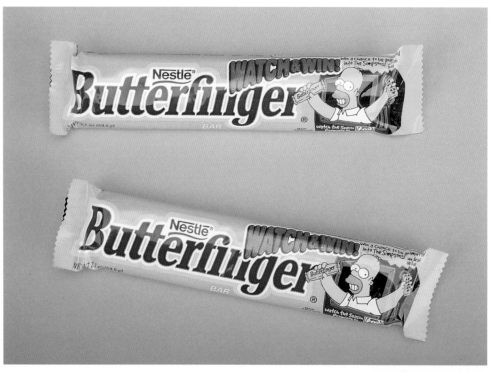

Butterfinger bars that offered viewers a chance to "Watch and Win" an opportunity to be animated into an episode of the show. 1999 Season Premiere contest. Nestle. $3-5.

Butterfinger BB's bags from Nestle, $2-4 each.

Butterfinger BB's bags from Nestle, $2-4 each.

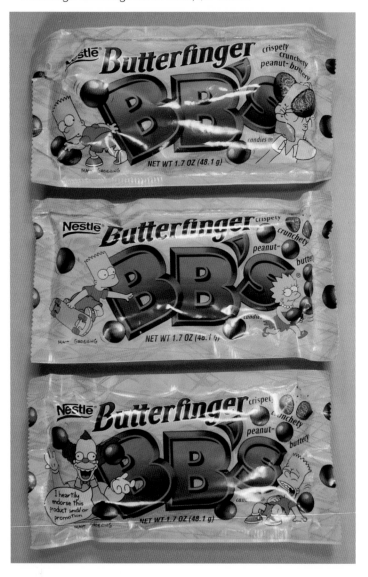

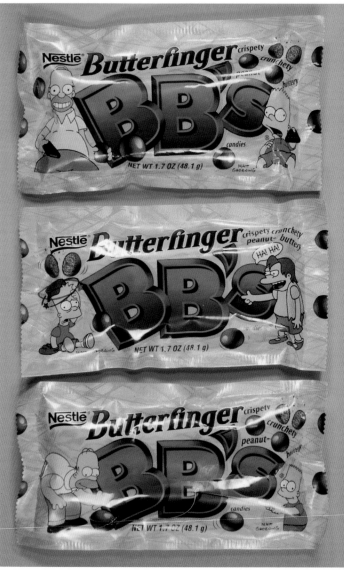

The "Lucky Dip" box came with a Milky Way bar, a Simpsons figurine, and a Simpsons Mini Collector card. Mars, Australia. See my first book, *The Simpsons*™ *Collectibles*, for a picture of the figurine set. $3-6 each.

Kit Kat wrappers from Nestle, U.K. $1-3 each.

Kit Kat wrappers from Nestle, U.K. $1-3 each.

Chapter Four: Bart's Bedroom
(Board/Video Games, Toys, Objets d' Bart)

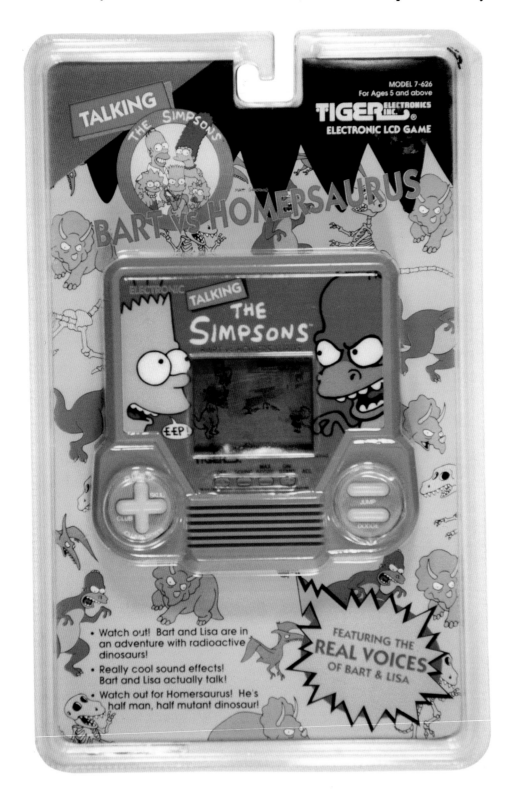

Bart vs. Homersaurus hand-held electronic game from Tiger Electronics. Bart actually did call Homer "Homersaurus" once, remember? So, of course, they, uh, made it into a game. Ahem. $30-$35.

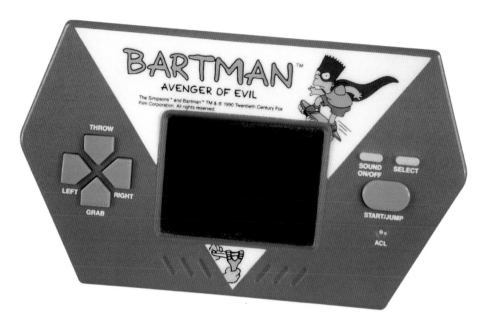

Bartman, Avenger of Evil hand-held electronic game from Acclaim. $15-20.

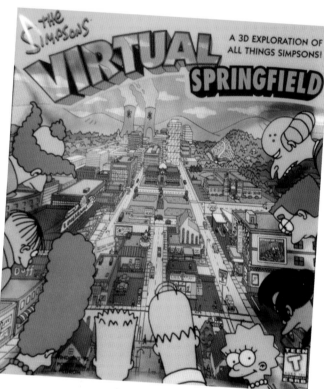

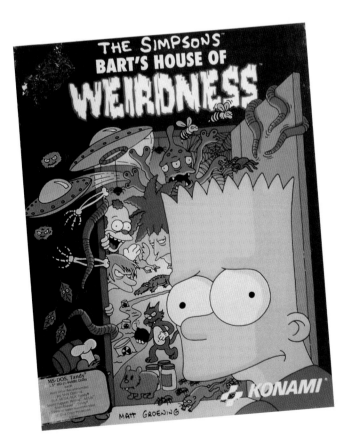

Virtual Springfield from Fox Interactive. This CD-Rom allowed the viewer to explore Springfield at his own pace, from Bart's bedroom to Moe's Tavern. $15-20.

Bart's House Of Weirdness game for the home computer from Konami. $20-25.

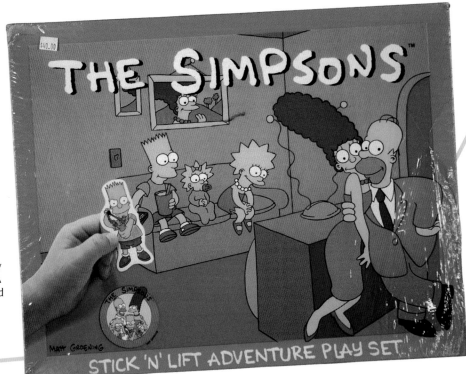

Simpsons Stick 'N' Lift Adventure Play Set from Paul Lamond Games, U.K. A larger version of the one that appeared in the first book. $25-35.

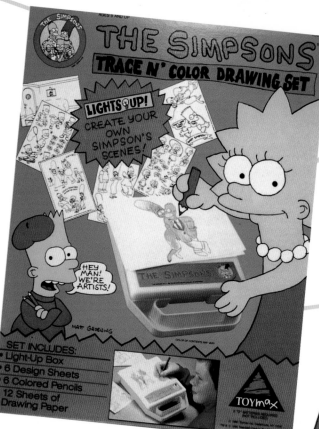

Simpsons Trace 'N' Color Drawing Set from Toymax. $15-20.

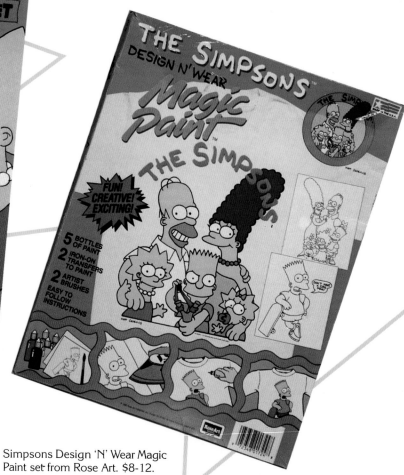

Simpsons Design 'N' Wear Magic Paint set from Rose Art. $8-12.

Simpsons Paint-By-Number set from Rose Art. $6-10.

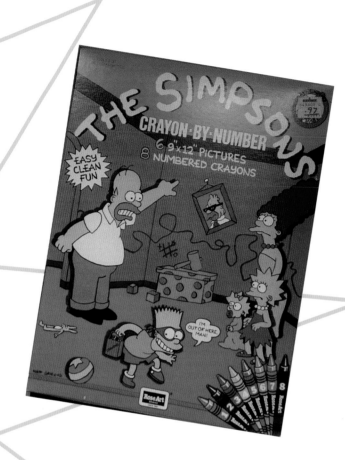

Simpsons Crayon-By-Number set from Rose Art. $8-12. *Courtesy of Greg Joseph.*

Simpsons Poster Pen Set from Rose Art. $8-12. *Courtesy of Greg Joseph.*

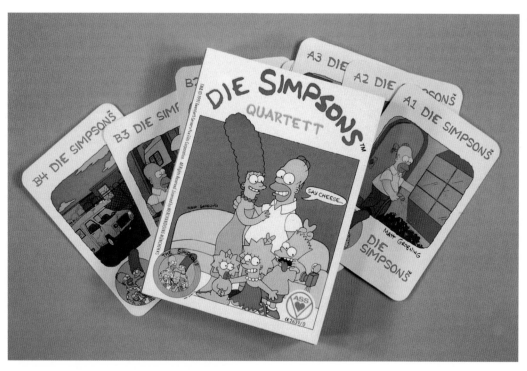

Die Simpsons Quartett card game from Altenburger und
Stralsunder, Germany. $15-20.

Simpsons Playing Cards from Tricorder, France. $12-15.

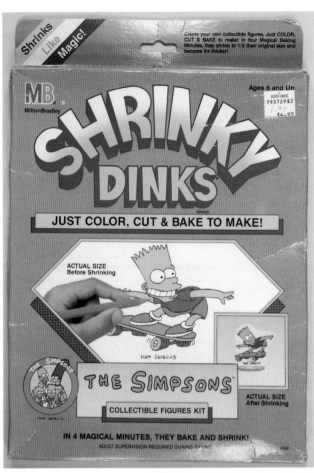

Simpsons Shrinky Dinks set from
Milton Bradley. $8-12.

Below:
Bart Simpson joystick from Cheetah, U.K. Readers
of the first book will more fully appreciate how
pleased I am to present this elusive critter. $40-60.

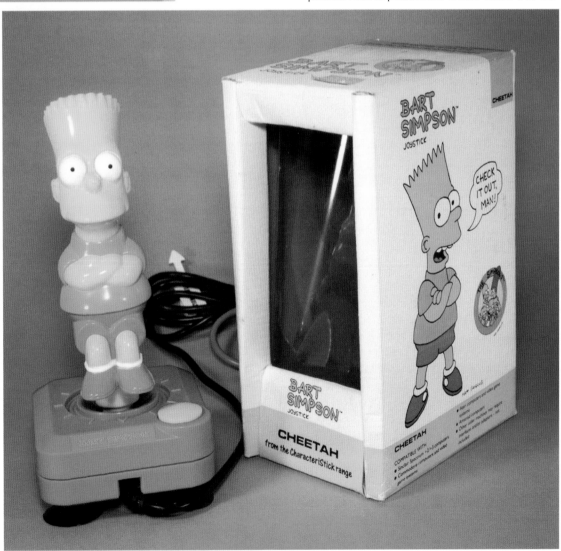

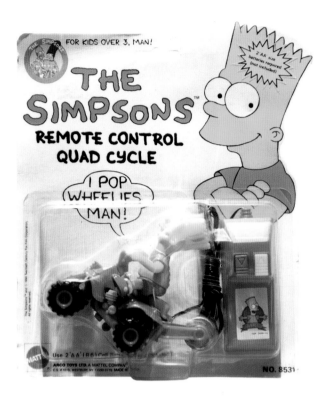

Bart Simpson Remote Control
Quad Cycle from Mattel. $35-45.

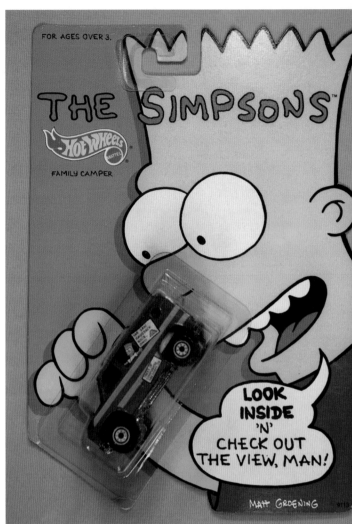

Simpsons Family Camper Hot Wheels from Mattel. Available with
three different scenes to view, and identified by three different
colored rims: blue, yellow, or chrome. $15-20.

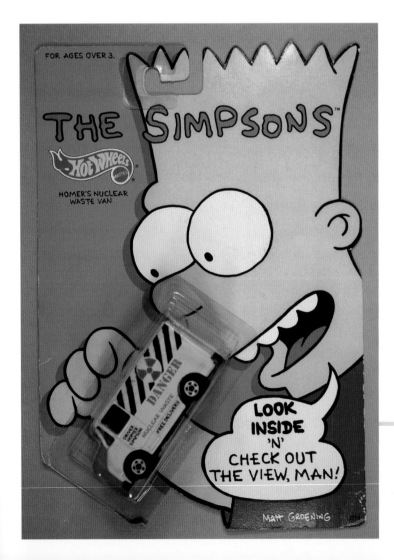

Homer's Nuclear Waste Van Hot Wheels from Mattel.
Also comes with three different scenes. $15-20.

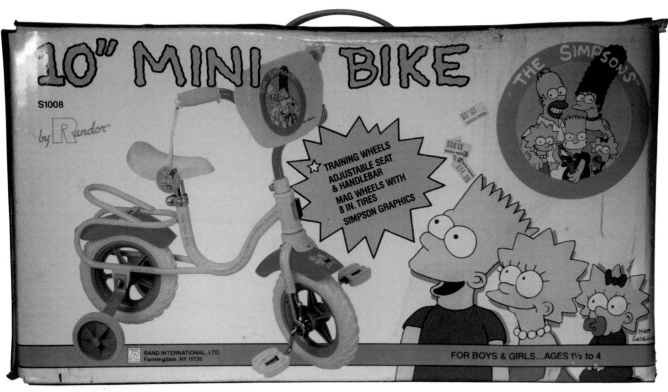

Simpsons 10" Mini Bike from Randor. $40-60. *Courtesy of Greg Joseph.*

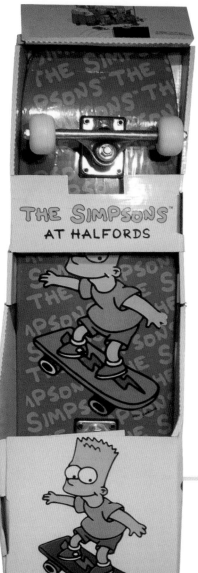

Homer Simpson Flip Face
game from Ja-Ru. $6-10.

Bart Simpson skateboard from Halfords,
U.K. $25-45. *Courtesy of Greg Joseph.*

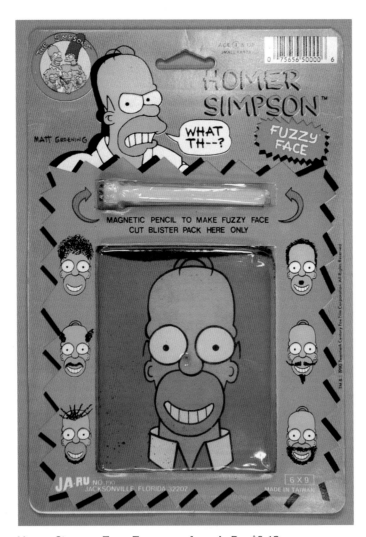

Homer Simpson Fuzzy Face game from Ja-Ru. $8-12.

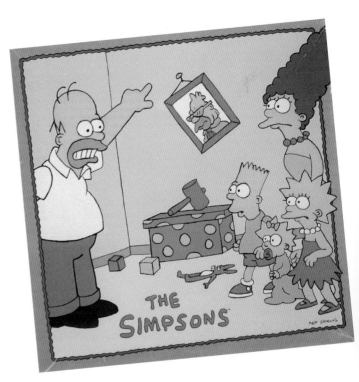

Simpsons puzzle from Milton Bradley. $6-10.

Lisa Simpson Stencil Set. Playmakers, U.K. $8-12. *Courtesy of Greg Joseph.*

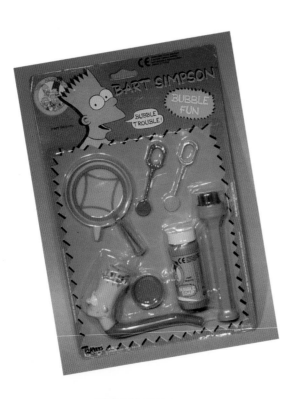

Bart Simpson Bubble Fun from Playmakers, U.K. $8-12. *Courtesy of Greg Joseph.*

Bart Simpson puzzle from
Milton Bradley. $6-10.

Simpsons Glow-In-The-Dark 60-piece Jigsaw
Puzzle from Glow Zone, Australia. $8-10.

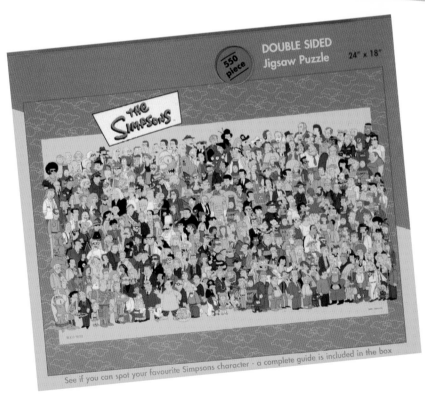

Simpsons 550-piece Double Sided Jigsaw
Puzzle from B.V. Leisure, U.K. There are over
300 supporting characters to find in this puzzle
based on the popular poster. $12-15.

Simpsons In The Dark stickers. Glow Zone, Australia. $8-10 each.

Simpsons Glow-In-The-Dark stickers. Glow Zone, Australia. $8-10.

Homer Simpson Dress Up Fridge Magnet set from Pancake Press, Australia. $12-15.

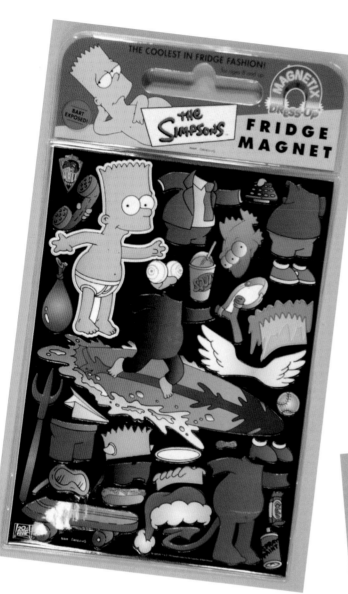

Bart Simpson Dress Up Fridge Magnet set
from Pancake Press, Australia. $12-15.

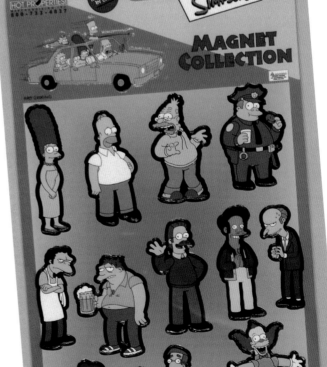

Simpsons Magnet Collection
from Hot Properties. $12-15.

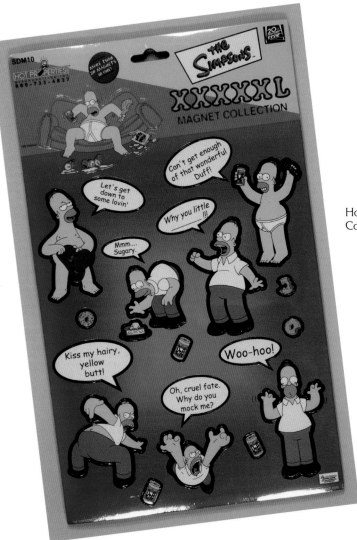

Homer Simpson XXXXXL Magnet
Collection. Hot Properties. $12-15.

Bart Simpson SK8-D-LUX Magnet
Collection. Hot Properties. $12-15.

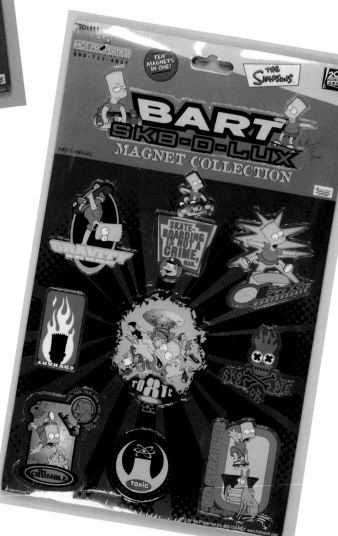

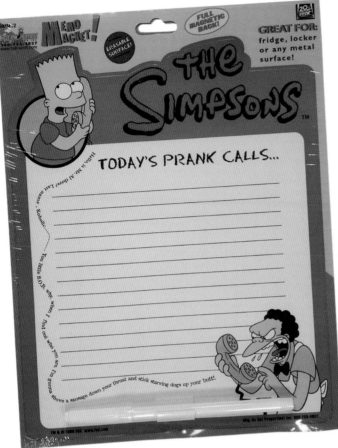

Bart Simpson and Moe Prank Call Memo
Magnet. Hot Properties. $12-15.

Simpsons Memo Magnet. Hot Properties. $12-15.

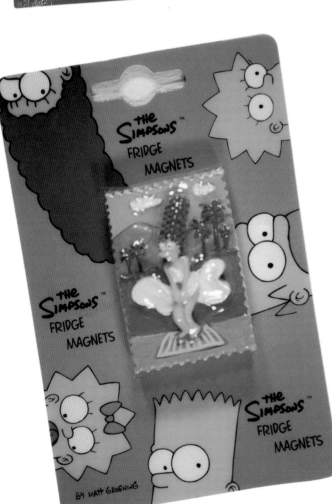

Marge Simpson Fridge Magnet from
Giftware Int'l, U.K. $5-8.

Simpsons Fridge Magnet from Giftware Int'l, U.K. $5-8.

Homer Simpson Fridge Magnet from Giftware Int'l, U.K. $5-8.

Mooning Bart Fridge Magnet from Giftware Int'l, U.K. Is there no end to the parade of unrepentant buttocks in this book? $5-8.

Bart Splash Fridge Magnet from Giftware Int'l, U.K. $5-8.

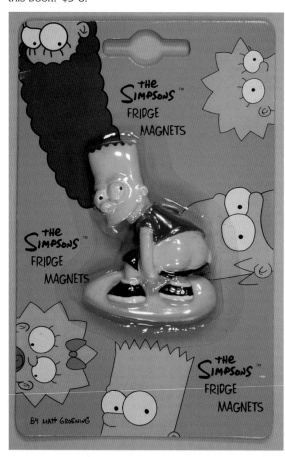

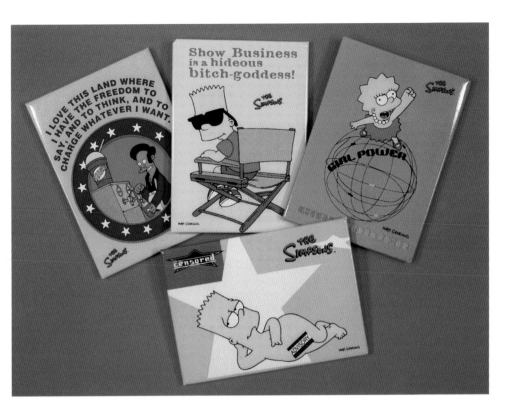

A small selection of the many Simpsons magnets released in 2000 by Hot Properties. $5-8 each.

Bart magnet from Germany and Maggie magnet from U.K. $5-8 each.

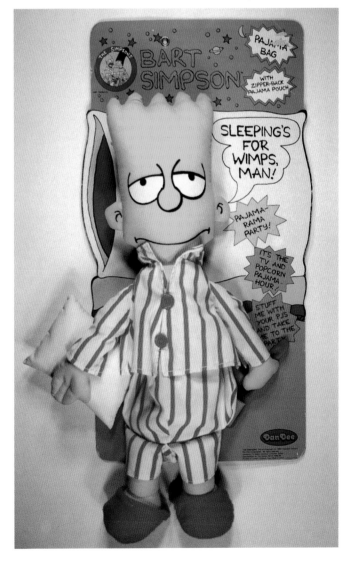

Bart Simpson Pajama Bag from Dan Dee. $25-40.

Homer Simpson Belt Bag from Kidz Biz, U.K. $8-12.

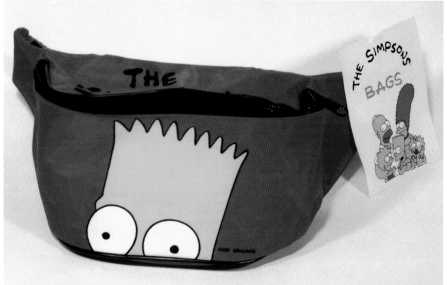

Bart Simpson Belt Bag from Kidz Biz, U.K. $8-12.

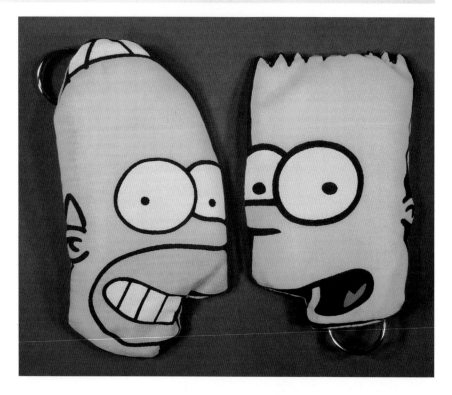

These Homer and Bart coin purses were promotional items available from Roda/Resi Margarine products in Belgium. $6-10.

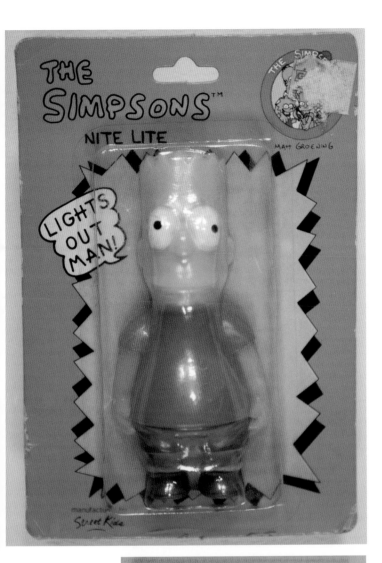

Bart Simpson Nite Lite from Street Kids. $8-12.

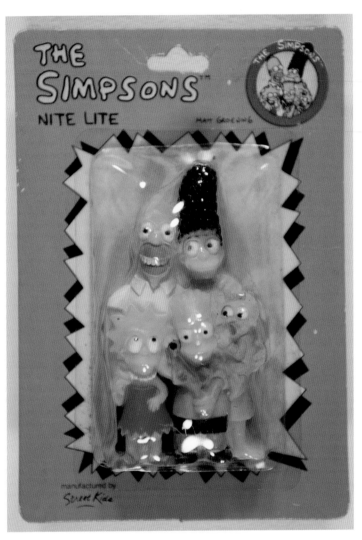

Simpsons Nite Lite from Street Kids. $8-12.

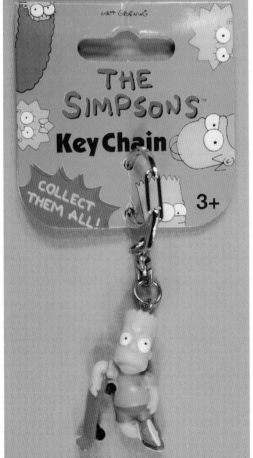

Bart Simpson keychain from
Vivid Imaginations, U.K. $3-6.

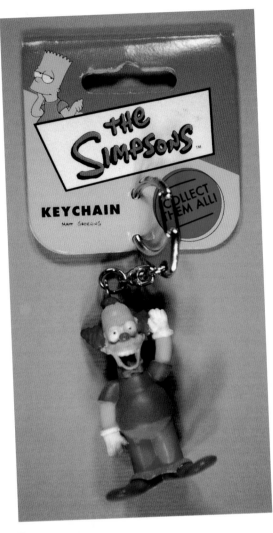

Krusty the Clown keychain. Vivid
Imaginations, U.K. $3-6.

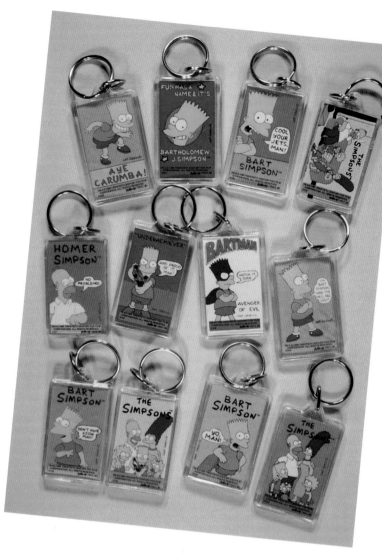

A selection of early Simpsons keychains from Button-Up. $3-6 each.

Recent keychains from Hot
Properties. $3-6 each.

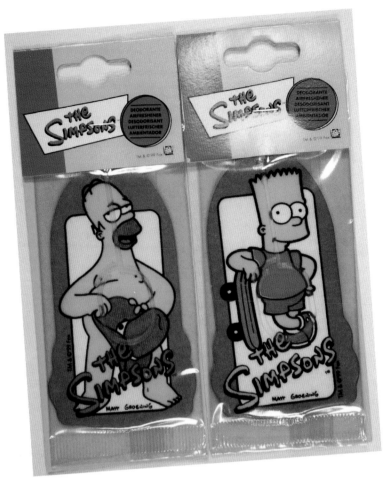

Bart and Homer Simpson Air Fresheners
from Eliocell, Italy. $5-8 each.

Simpsons Air Freshener. Eliocell,
Italy. $5-8.

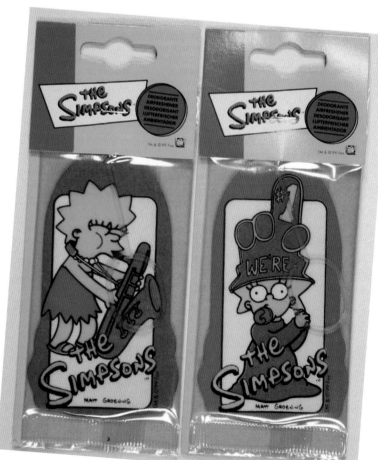

Lisa and Maggie Simpson Air
Fresheners. Eliocell, Italy. $5-8 each.

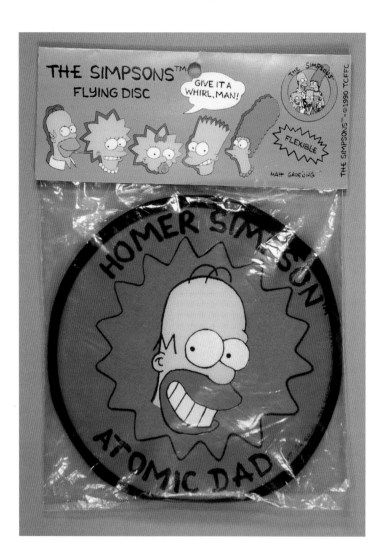

Homer Simpson Atomic Dad
Flying Disc from J.G. Hook. $8-12.

Simpsons Flying Disc from J.G. Hook. $8-12.

Simpsons Self-Adhesive Book Cover can from Dolores Almeda, Spain. $20-30. *Courtesy of Greg Joseph.*

Mr. Burns doorknob sign from Tonnerre, France. $5-8.

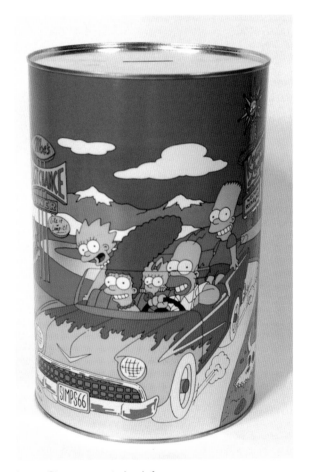

Large Simpsons coin bank from Dalson, Australia. $15-25.

Simpsons coin banks from Distriferia, Italy. $8-12 each.

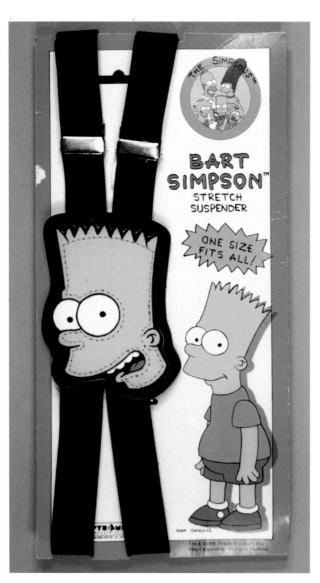

Bart Simpson Stretch Sus-
penders from Pyramid. $12-15.

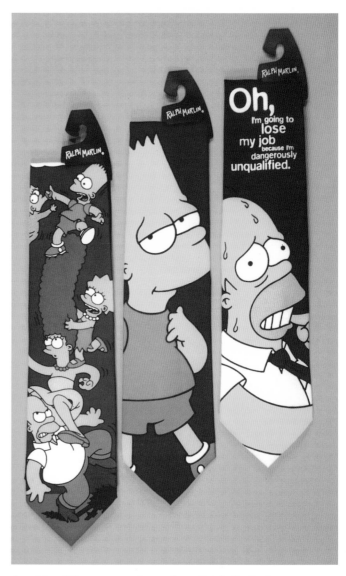

A variety of Simpsons neckware from Ralph Marlin. Impress your
boss the way Homer impresses Mr. Burns. $12-15 each.

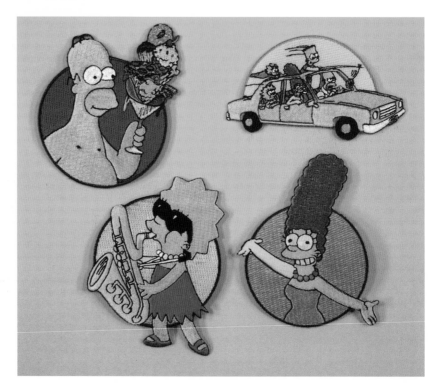

Simpsons patches from C&D
Visionary. $5-8 each.

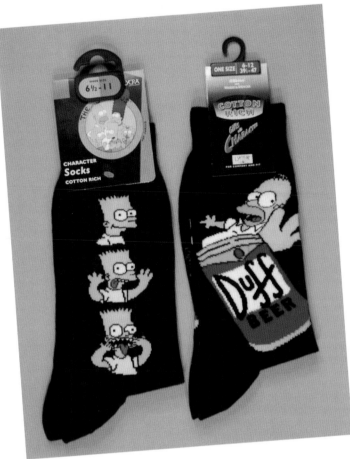

Bart Simpson socks from Essentials, U.K., $8-12. Homer Simpson socks from Marks and Spencer, U.K., $8-12.

Just looking at these makes me feel more comfortable. Homer Simpson boxer shorts from Essentials, U.K. $10-12.

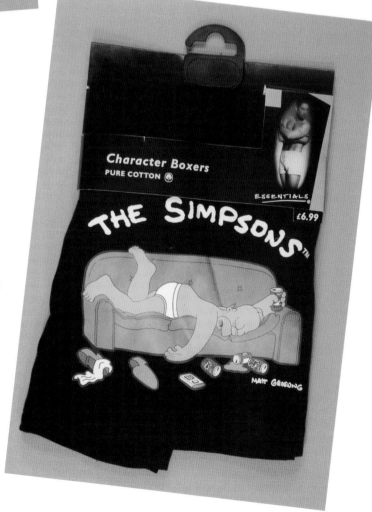

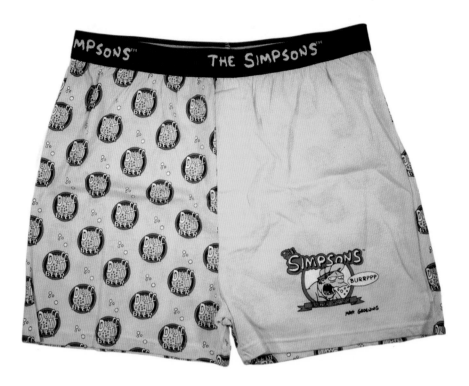

Duff Beer boxer shorts from J.C. Penney. $8-12.

Christmas Bart boxer shorts from Boxer Rebellion. $12-16.

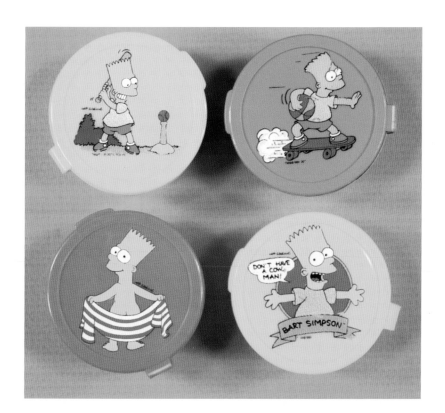

Pog holders from Quick Restaurants, Belgium. $6-10 each.

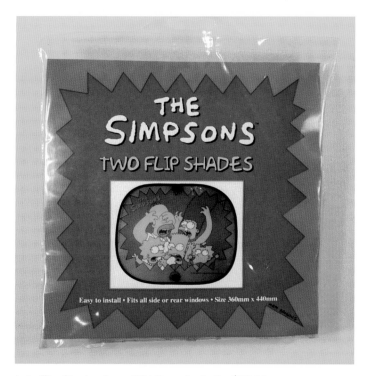

Auto Flip Shades from JNH Toys, Australia. $12-15.

Bart Simpson novelty pillow, manufacturer unknown. $3-6.

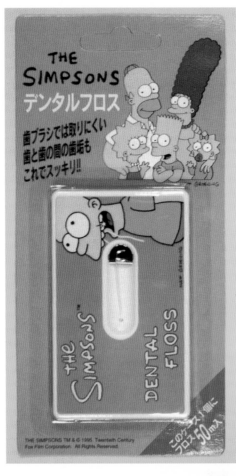

Simpsons Dental Floss
from Feed, Japan. $5-8.

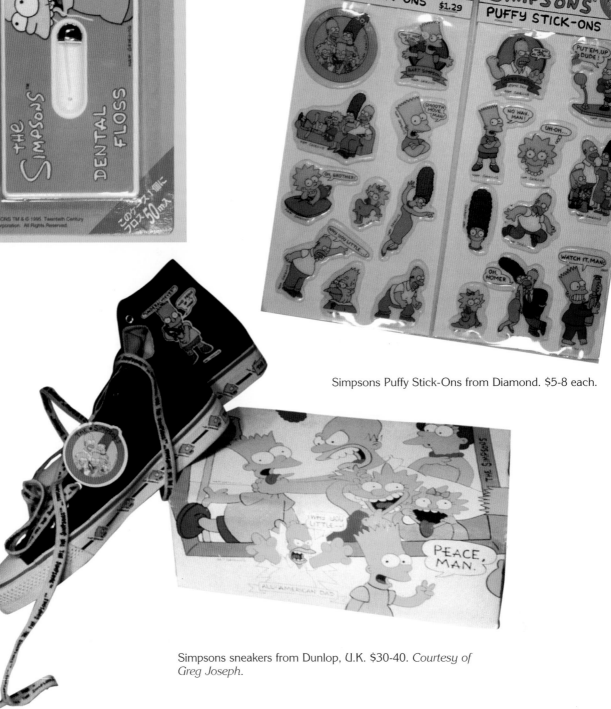

Simpsons Puffy Stick-Ons from Diamond. $5-8 each.

Simpsons sneakers from Dunlop, U.K. $30-40. *Courtesy of Greg Joseph.*

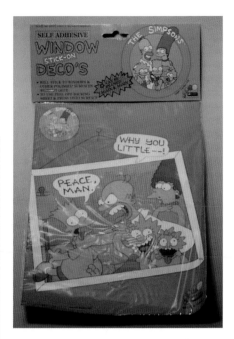

Simpsons Stick-On Window Deco's
from Jotastar, U.K. $10-15.
Courtesy of Greg Joseph.

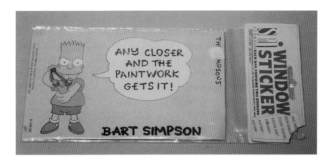

Bart Simpson Window Sticker from Scorpio, U.K. $3-6
each. *Courtesy of Greg Joseph.*

Simpsons temporary tattoos
from Sasun, Brazil. $5-8 each.

Bart Simpson stickers from
Rotola, Brazil. $3-6 each.

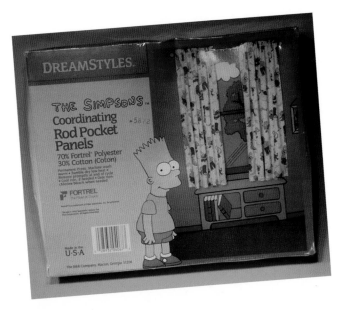

Simpsons Rod Pocket Panels from Fortrel.
$20-30. *Courtesy of Greg Joseph.*

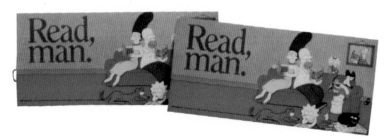

"Read, Man" bookmarks from the American Library
Association. Also available as a poster. $2-4.

Squeeze Bart, no manufacturer indicated. $5-8.

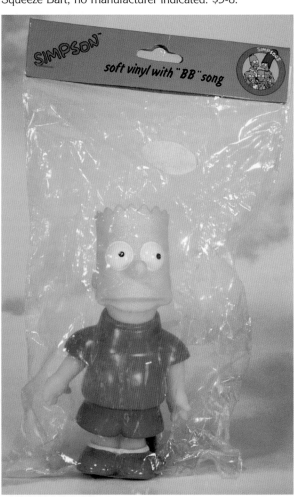

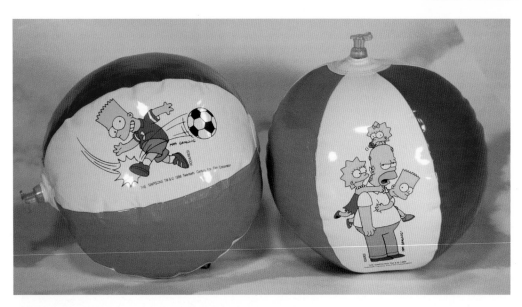

Blow-up ball premiums from Roda/
Resi, Belgium. $8-12 each.

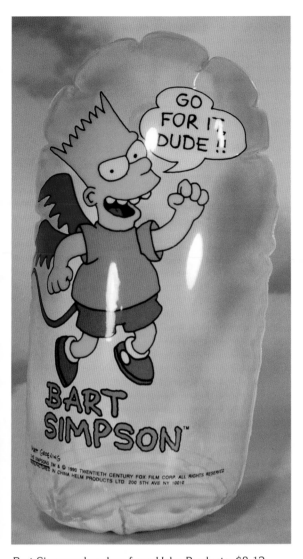

Bart Simpson bop bag from Helm Products. $8-12.

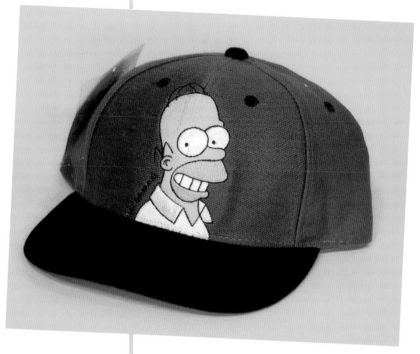

Homer Simpson cap from Top Heavy. $12-15.

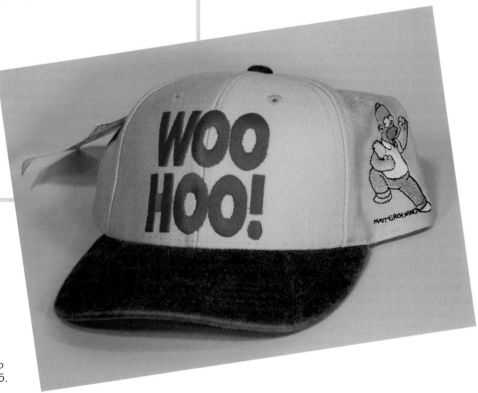

Homer "Woo Hoo!" cap
from Top Heavy. $12-15.

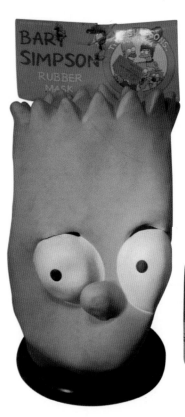

Early Bart Simpson
Rubber Mask from Ben
Cooper. $20-25.

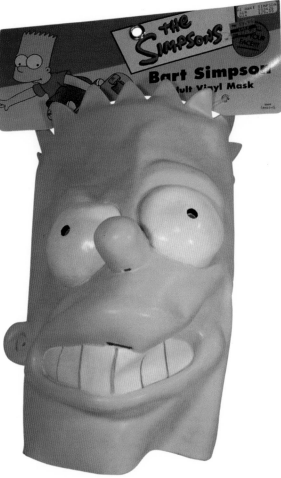

Bart Simpson Vinyl Mask from
Disguise, Inc. $25-35.

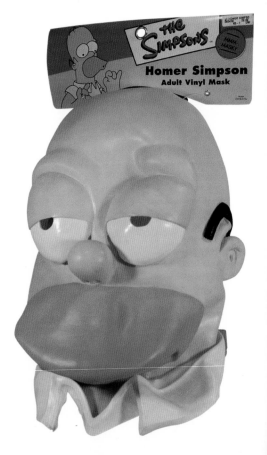

Homer Simpson Vinyl Mask from
Disguise, Inc. $25-35.

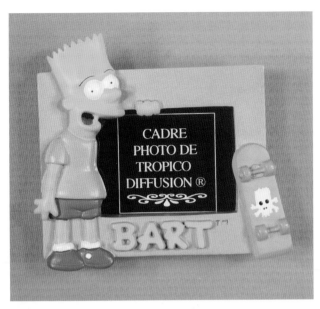

Small Bart Simpson picture frame from Tropico, France. A larger version of this appeared in my first book. $12-15.

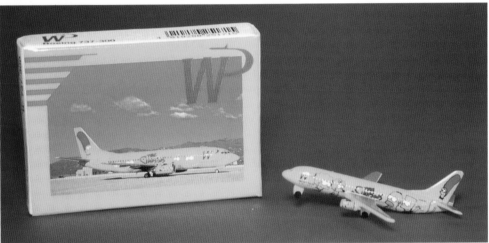

Die-cast model of the Western Pacific Simpsons plane from Schabak, Germany. 1/600 scale. $12-15.

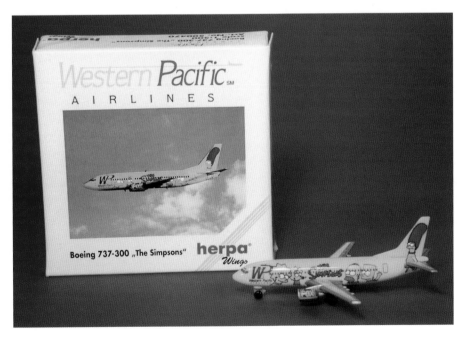

Die-cast model of the Western Pacific Simpsons plane from Herpa, Germany. 1/500 scale. $15-20.

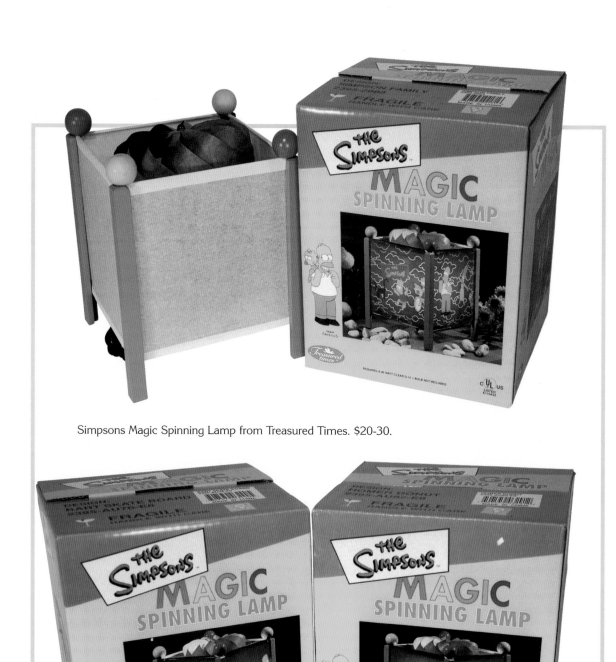

Simpsons Magic Spinning Lamp from Treasured Times. $20-30.

Bart and Homer Simpson Magic Spinning Lamps. Treasured Times. $20-30 each.

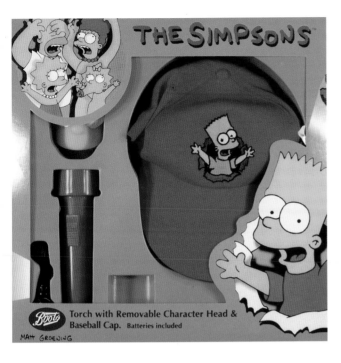

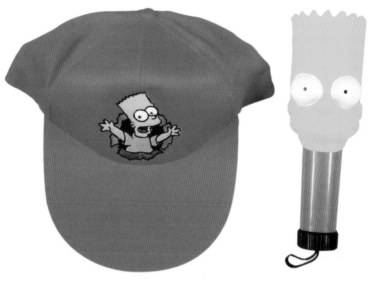

Baseball cap and flashlight.

Simpsons Torch (flashlight) with Bart head and
Baseball cap from Boots, U.K. $25-35.

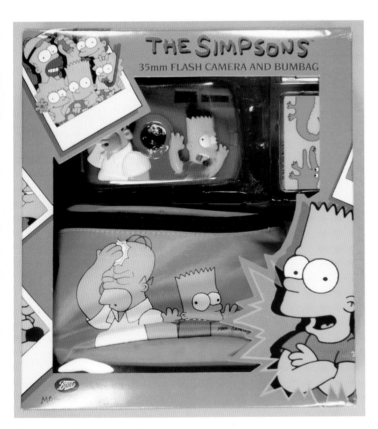

Homer and Bart 35mm Flash Camera
and Bumbag from Boots, U.K. $35-50.

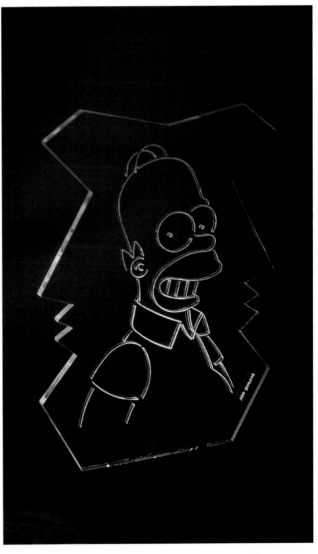

Limited edition Homer Simpson laser sculpture by Buzzy
Trusiani. A whole series of *Simpsons* sculptures were pro-
duced, with their limitation dictating the price. $60-75.

Chapter Five: Lisa's Bedroom
(Clocks/Watches, School Supplies, Hair Accessories)

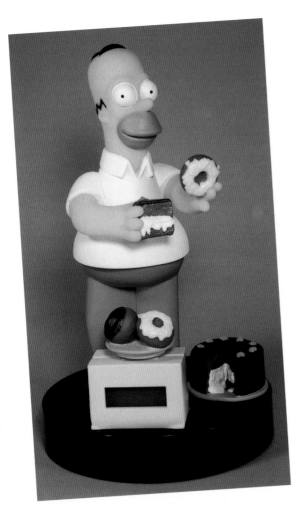

Homer Simpson Talking Alarm
Clock from Wesco, U.K. $25-30.

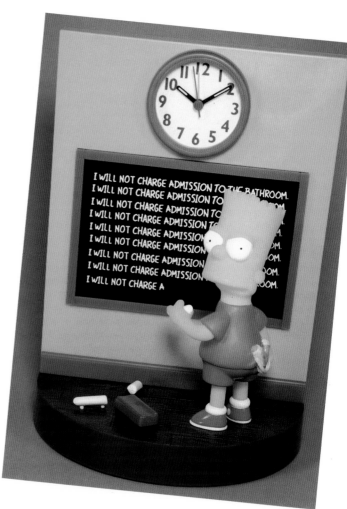

Bart Simpson Talking Alarm Clock.
Wesco, U.K. $25-30.

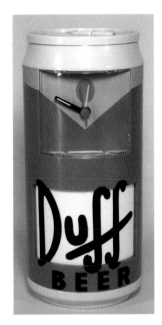 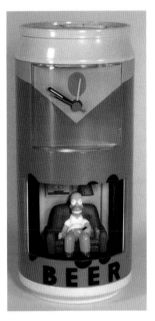

Duff Beer Alarm Clock. Wesco, U.K. When the alarm goes off, the "Simpsons Theme" plays as the Duff logo parts to reveal. . .

. . . this modern Adonis. $25-30.

Simpsons Wall Clock. Wesco, U.K. $20-25.

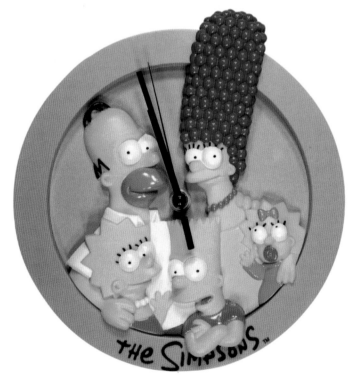

Hey, watch that second hand, man!

Homer Simpson Wall Clock.
Wesco, U.K. $8-12.

Bart Simpson Wall Clock.
Wesco, U.K. $8-12.

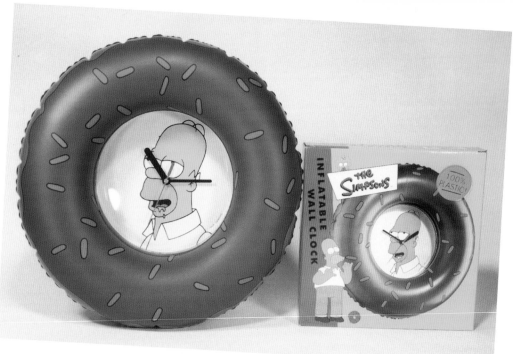

Homer Simpson Inflatable Wall
Clock. Wesco, U.K. $8-12.

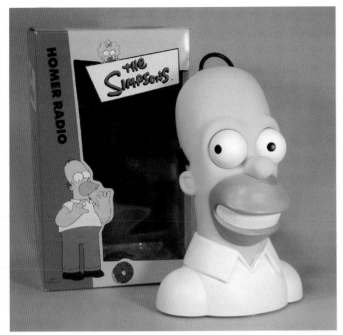

Homer Simpson Radio. Wesco, U.K. Twist Homer's bulgy eyes to locate your favorite station. $20-25.

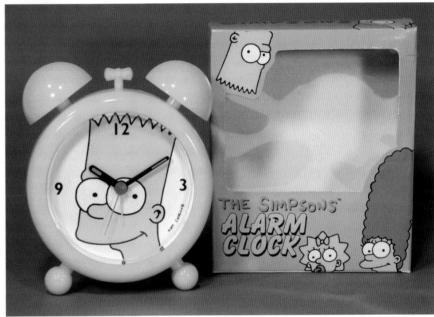

Bart Simpson Alarm Clock. Wesco, U.K. $10-15.

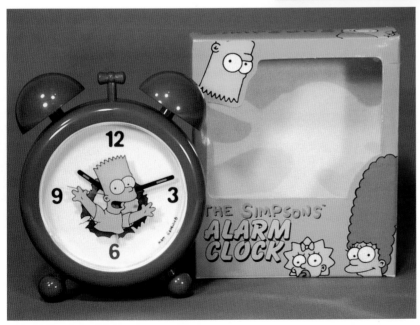

Bart Simpson Alarm Clock. Wesco, U.K. $10-15.

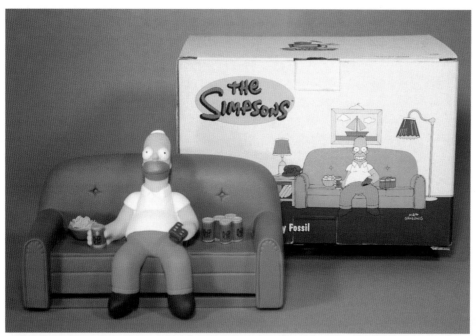

Homer Simpson Limited Edition Watch from Fossil. This limited watch came in both a silver edition of 3,000 and a gold edition of 500. The beautifully rendered Homer "case" (shown here) is almost worth the price of admission by itself. Silver, $75-90, Gold, $120-140.

Below:
Bart Simpson Limited Edition Watch from Fossil. This limited watch came in both a silver edition of 3,000 and a gold edition of 500. A special picture frame was also included. Silver, $75-90, Gold, $120-140.

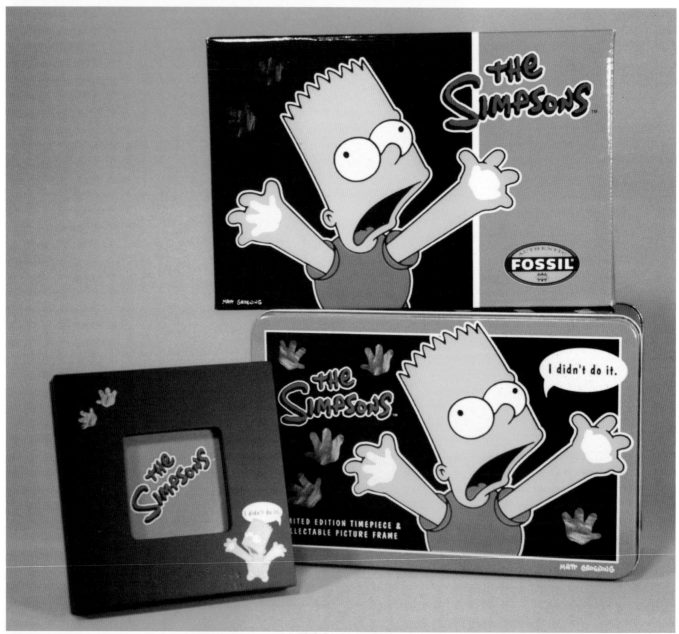

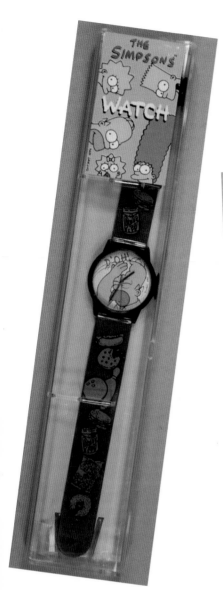

Homer Simpson "D'oh!"
watch from Wesco, U.K.
$12-15.

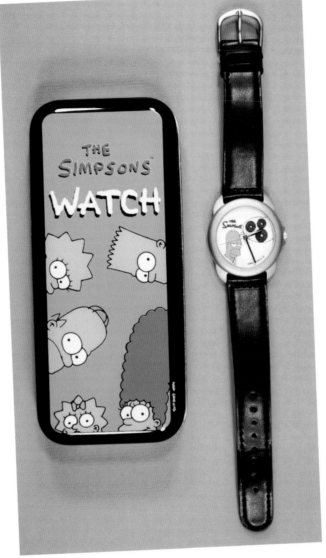

Homer Simpson Donut watch. Wesco, U.K. $15-20.

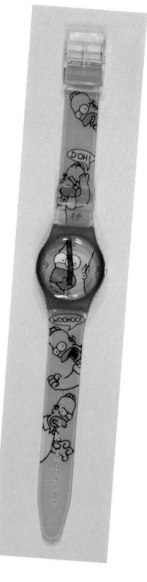

Kit Kat promotional watch. Wesco, U.K.
There was also a Bart version that reversed
the yellow and red color scheme. $20-25.

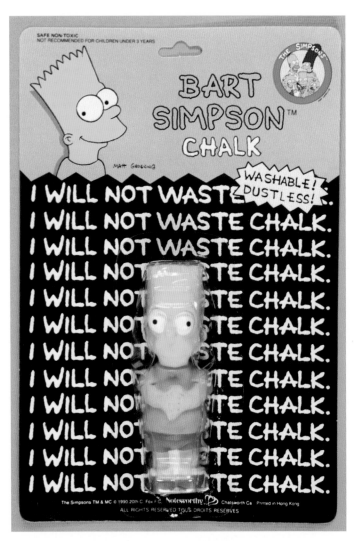

Bart Simpson Chalk from Noteworthy. $8-12.

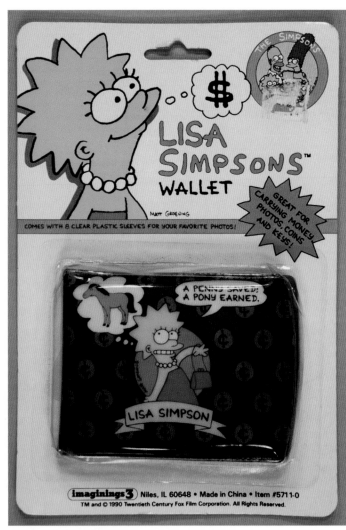

Lisa Simpson Wallet from Imaginings3. $8-12.

Large Bart Simpson pencil case from Australia. $10-15.

Large Homer Simpson pencil case from Australia. $10-15.

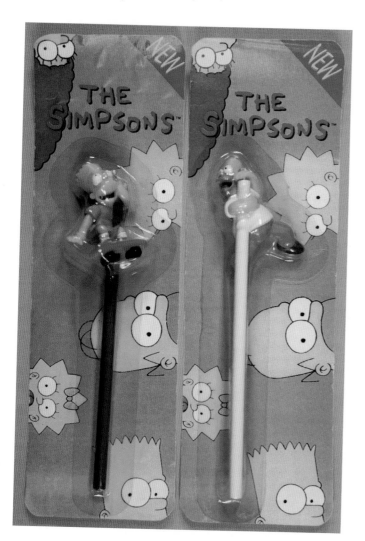

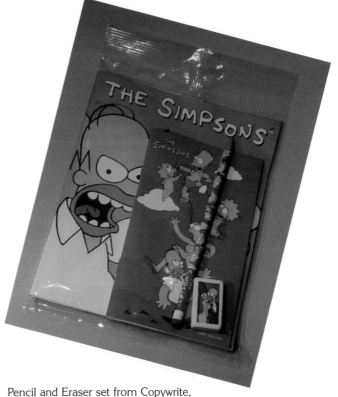

Pencil and Eraser set from Copywrite,
U.K. $5-8. *Courtesy of Greg Joseph.*

Bart and Homer Simpson pencil toppers
from Vivid Imaginations, U.K. $5-8.

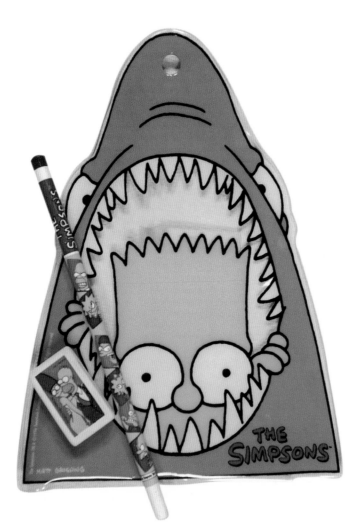

Bart Simpson Pencil and Eraser set. Copywrite, U.K. $6-10.

Simpsons spiral notebook from Legends. $3-6. *Courtesy of Greg Joseph.*

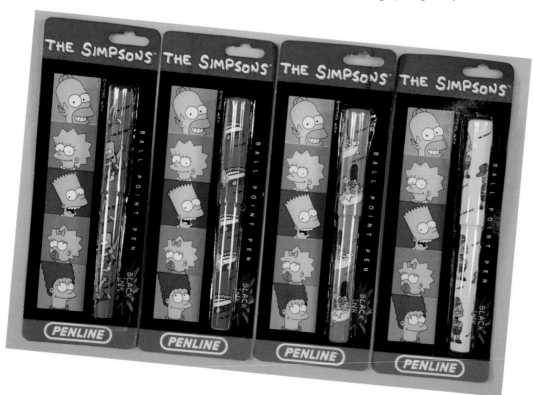

Simpsons Ball Point pens from Penline, Australia. $3-5 each.

Notepad set and Photo Album from Copywrite, U.K. $8-12 each. *Courtesy of Greg Joseph.*

Jumbo pen set, self stick notes, and pencil/eraser set from Copywrite, U.K. $7-10 each. *Courtesy of Greg Joseph.*

Bart Simpson loose leaf binder from Legends. $5-8.

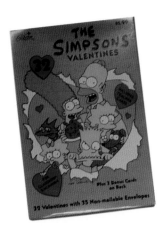

Simpsons Valentines from
Gibson. $3-6. *Courtesy of
Greg Joseph.*

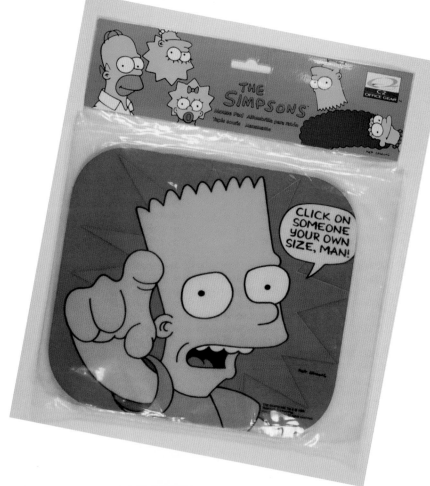

Bart Simpson Mouse Pad from
Office Gear. $8-12.

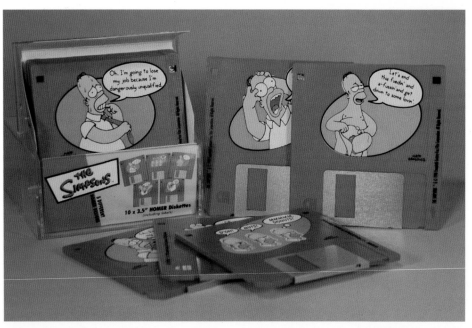

Homer Simpson Computer Diskettes
from Mousepad Co., U.K. Here's where
Technology meets Incompetency. $10-15.

Chapter Six: Living Room
(Cels and Drawings, CD's, Tapes and Videos)

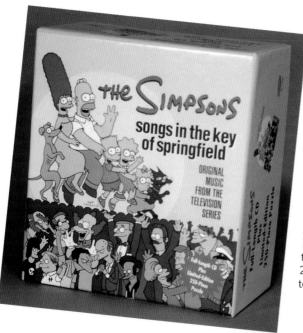

Songs In The Key Of Springfield, special limited edition. This boxed version of their first Rhino album comes with a free 250-piece puzzle of the cover in addition to the CD itself. Rhino, 1999. $20-30.

The Yellow Album, Geffen. This mysterious artifact finally saw the light of day, no doubt helped along by the success of the Rhino album. *The Yellow Album* was the oft-rumored sequel to *The Simpsons Sing The Blues* and was scheduled for release until it was scrapped without any explanation. The track around which most of the gossip focused is not present, however: "My Name Is Bart," which supposedly featured Prince, isn' t here, although there are reportedly advance copies floating around which include it. $12-18.

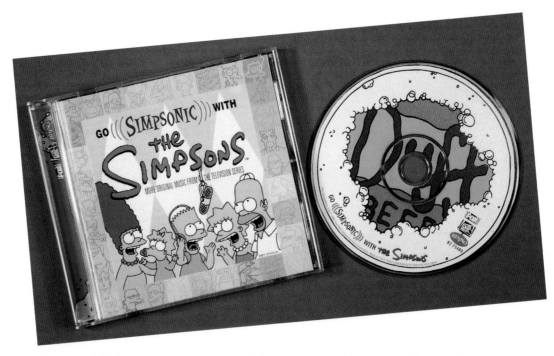

Go Simpsonic With The Simpsons, Rhino, 1999. The long-awaited follow-up to *Songs* did not disappoint and included previously unreleased material, such as *I Love To Smoke*, a Patty and Selma number intended for the Shary Bobbins episode. Also includes my very favorite version of the *Simpsons* theme, as performed by Sonic Youth. Hear it here: they talk all over it in syndication. $12-18.

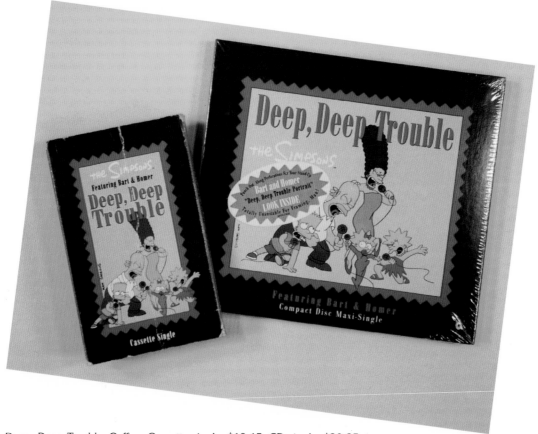

Deep, Deep Trouble, Geffen. Cassette single, $10-15, CD single, $20-25.

The Simpsons Cartoon Studio, Fox Interactive. Animate your own cartoons with the help of this handy CD. This cheaper version originally came in a larger box, much like *Virtual Springfield.* $12-15. *This Is Springfield, Not Shelbyville!* Boy, do I love this. A collection of straight edge punk bands doing songs from and/or inspired by *The Simpsons,* with excerpts from the show that are just short enough to keep the lawyers at bay. Imagine Ramones-style versions of *See My Vest* or *Who Needs The Kwik-E-Mart?* and you'll have some idea of the hyperactive hijinks going on here. Pick to click: *Zombie Flanders.* Mmmmm, moshilicious. $15-20.

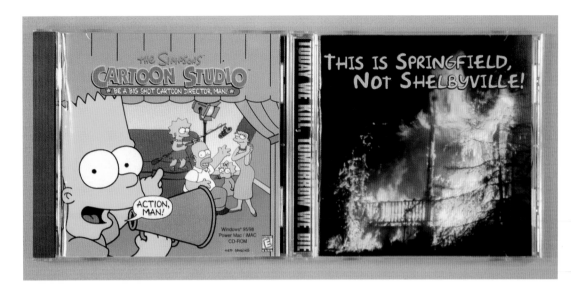

Right:
The Best Of The Simpsons, Volumes 4, 5, and 6 box set and Volumes 7, 8, and 9 box set. 20th Century Fox. $15-20 each.

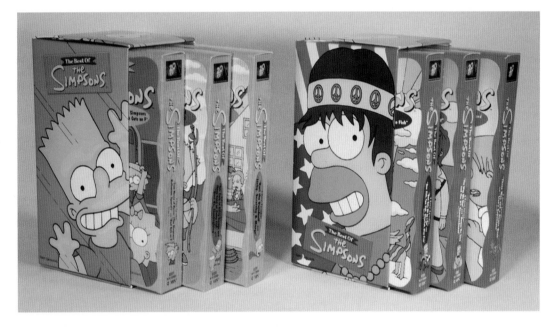

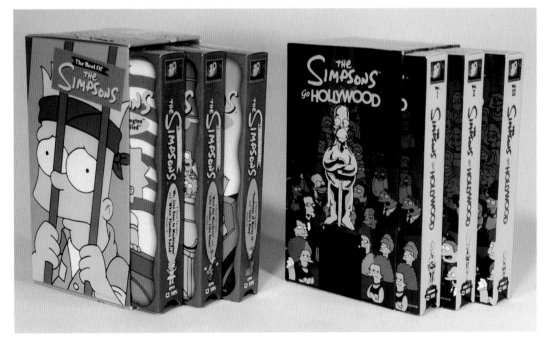

The Best Of The Simpsons, Volumes 10, 11, and 12 box set and *The Simpsons Go Hollywood,* Volumes 1, 2, and 3. 20th Century Fox. $15-20 each.

Chapter Seven: Books/Comic Books/Magazines

The publishing side of *The Simpsons* remains an extremely healthy enterprise: witness the continuing stream of books and comics represented here. Bongo Comics recently celebrated the 50th issue of *Simpsons Comics* with an 80-page spectacular, after which it began to appear on a monthly, rather than bi-monthly, basis. A *Bart Simpson* title designed for younger readers has debuted, as has a comic book version of *Futurama*. In September of 1999, The Simpsons made their debut on the pages of the Sunday funnies. Amazingly, the show proved it was still capable of generating controversy when a Christmas-themed Itchy and Scratchy segment ("It's A Wonderful Slice!") caused some papers to drop the strip. Here's a list of the segments that appeared during the strip's first six months. The titles are our own:

A *Simpsons* Sunday Funnies Checklist

9/5/99 — Homer's Chores
9/12/99 — A Froggy Day In Lisa's Class
9/19/99 — The Burns Paradox
9/26/99 — Milhouse's Magazines
10/3/99 — Retrace Homer's Steps
10/10/99 — Dark Angel Of Donuts
10/17/99 — Ralph Saves The Day
10/24/99 — Bart's Clip 'N' Save Coupons
10/31/99 — Good Fellowship
11/7/99 — Springfield Community Theater
11/14/99 — Apu's Photo Booth
11/21/99 — Bart's Nickname Wheel
11/28/99 — Grampa's Errand
12/5/99 — Ned Pays His Taxes
12/12/99 — If These Crumbs Could Talk
12/19/99 — Itchy and Scratchy in: "It's A Wonderful Slice!"
12/26/99 — Wedgie Time
1/2/00 — One Flew Over The Retirement Castle
1/9/00 — Hurricane Nixon Hits Springfield
1/16/00 — A Slack-Jawed Yokel's Guide To Entertaining
1/23/00 — Homer's Extra Arm
1/30/00 — Trouble At Moe's
2/6/00 — Don't Doubt It Or Do!

2/13/00 — *Peanuts* Tribute
2/20/00 — Milhouse Magoo
2/27/00 — Marge's Birthday
3/5/00 — The Burns Estate
3/12/00 — Simpsons Round The World

Simpsons Comics On Parade from HarperPerennial, 1998. Collects *Simpsons Comics* #24 through #27. $10-15.

Simpsons Comics Big Bonanza. HarperPerennial, 1998. Collects *Simpsons Comics* #28 through #31. $10-15.

Simpsons Comics A Go-Go. HarperPerennial, 1999. Collects *Simpsons Comics* #32 through #35, plus #10. $10-15.

The Simpsons Guide To Springfield. HarperPerennial, 1998. $10-15 each.

The Simpsons Forever! A sequel to the best-selling *Complete Guide*. Highlights include a tribute to Troy McClure. HarperPerennial, 1999. $15-18 each.

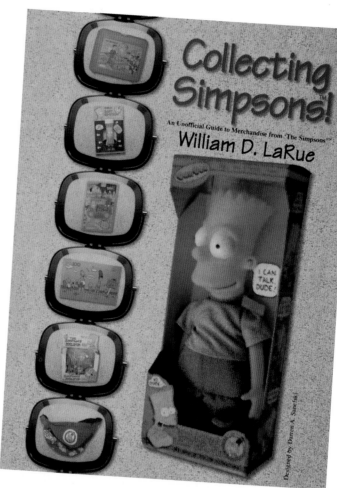

Collecting Simpsons! This guidebook from the webmaster of the *Collecting Simpsons* website, William D. LaRue, features extensive lists of Simpsons merchandise, as well as many representative photos. KML Enterprises. $20-25.

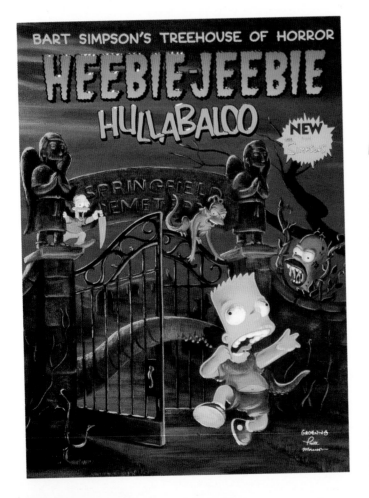

Bart Simpson's Heebie Jeebie Hullabaloo. HarperPerennial, 1999. A collection of the best stories from Bongo Comics' ongoing *Treehouse Of Horror* series. Oversized, with embossed design on cover. $15-18 each.

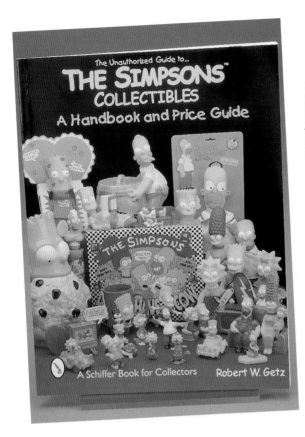

The Unauthorized Guide To The Simpsons Collectibles by Robert W. Getz. Schiffer Publishing, 1998. Hey, you know what's cool about this book? It's, like, about *Simpsons* collectibles, but it's also kind of a *Simpsons* collectible itself. You know, the way Kramer's coffee table book was actually a coffee table? Whoa. $30-35.

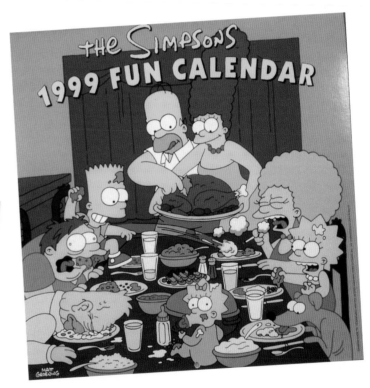

The Simpsons 1999 Fun Calendar from Harper Horizon. $12-18.

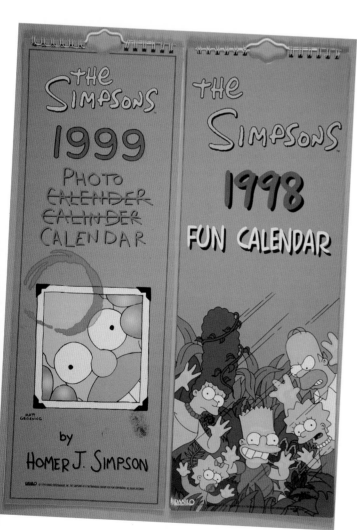

Simpsons Fun Calendar, 1998 and 1999 from Danilo, U.K. $12-18 each.

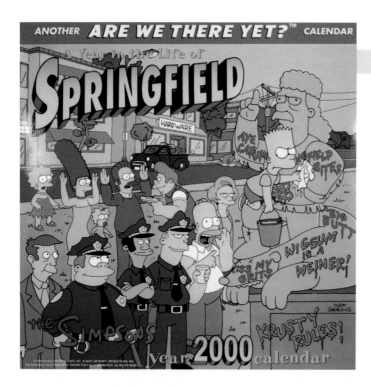

A Year In The Life Of Springfield: The Simpsons Year 2000 Calendar from Harper Entertainment. $12-18.

Entertainment Weekly, #14, May 18, 1990. Before *EW* could afford a capital "E" in their title, they ran this early cover. $8-12.

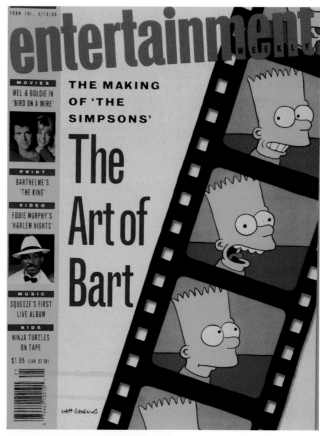

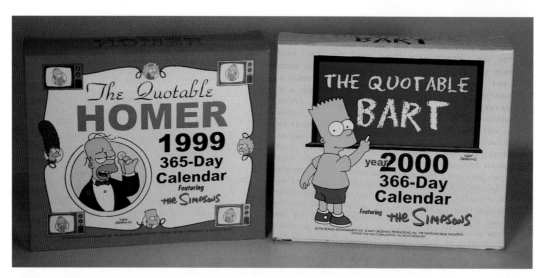

The Quotable Homer 1999 365-Day Calendar from Harper Horizon, and *The Quotable Bart Year 2000 366-Day Calendar* from Harper Entertainment. Pithy, bite-sized quotes for every day of the year are provided by these beautifully designed desk calendars. And, of course, four quotes make a gallon. $12-18 each.

Newsweek, April 23, 1990. $8-12.

The Web, Volume 2, Number 2, Feb. 1998. $5-10.

Script, Vol. 5, No.5, 1999. $5-10.

Cult TV, January 1998. Worth it for the cover alone. $8-12.

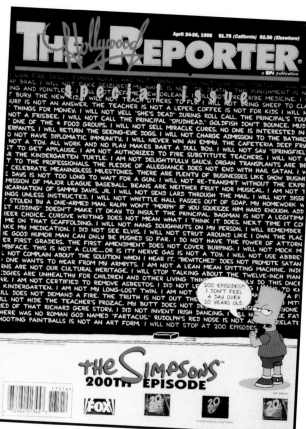

The Hollywood Reporter, Special Issue, April 24-26, 1998. Celebrating the 200th episode of *The Simpsons* with the ultimate blackboard gag. $5-8.

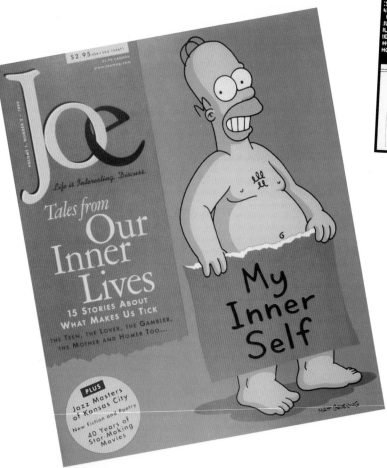

Joe, Volume 1, Number 2, 1999. The *Starbucks* house organ gives you a glimpse of Homer's Inner Self. $5-8.

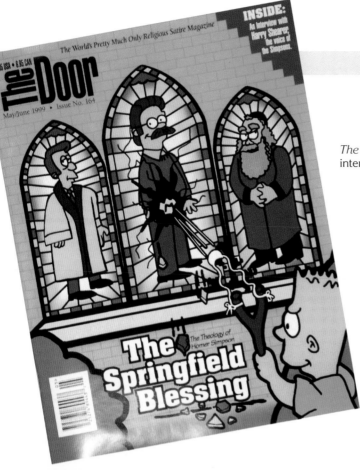

The Door, #164, May/June 1999. Includes an interview with Harry Shearer. $5-10.

Flux, #6, 1995. $5-8.

Entrepreneur's Business Start-Ups, Vol. 11, No. 2, February 1999. The obvious poster boy for the new economy. $5-8.

Simpsons Collector's Guide, insert with *ToyFare,* June 2000 issue. This guide took you behind-the-scenes and ran down what was in store for the Playmates "interactive" figures. $3-5.

TV Guide, Oct. 17-23, 1998. $3-6.

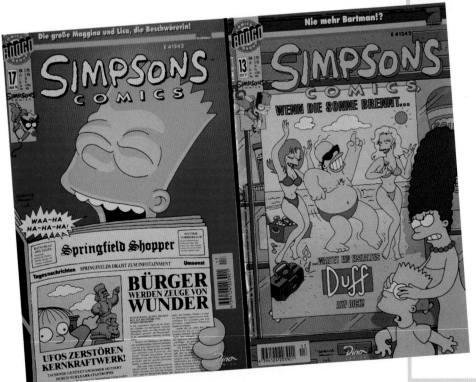

Simpsons Comics, #17 and #13 from Dino, Germany. $5-8 each.

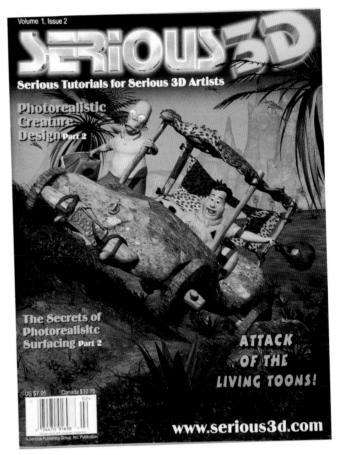

Serious 3-D, Volume 1, Issue #2, 1998. Together at last, Homer and Fred Flintstone make their way to the nearest bowling lane. But will their allegiance be to The Grand Poobah or the Head Stonecutter? $7-12.

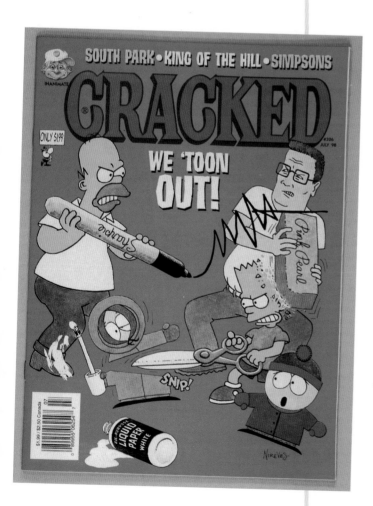

Cracked, #326, July 1998. $5-8.

Chapter Eight: Buttons/Pins

Every summer, comic geeks descend by the thousands upon the fair city of San Diego. The reason is the *San Diego Comic Con (SDCC)*, the largest event of its kind and the one at which publishers pull out all the stops in their efforts to make the faithful aware of what's in the pipeline for the coming year.

Since the inception of the *Bongo Comics Group*, promo pins and other collectibles have been a mainstay at the *Bongo* booth in San Diego. We're very grateful to Nobby Coburn for providing the following list of pins and promos related to *The Simpsons* and *Bongo Comics*.

1994 SDCC Bongo Pins:
1) Lisa Simpson — The Secret Files of Lisa Simpson.
2) Krusty — *Krusty Comics*.

1995 SDCC Bongo Pins:
1) Lisa Simpson — *Treehouse of Horror* (Lisa being strangled by vine).
2) Bart Simpson — *Treehouse of Horror* (Bart with cat-like shadow).
3) Homer Simpson — *Treehouse of Horror* (Homer as dinner for Moby Dick).
4) *Roswell* — Bill Morrison's comic.
5) *Jimbo* — Gary Panter comic published by sister imprint *Zongo*. (red)
6) *Jimbo* — Gary Panter comic published by sister imprint *Zongo*. (yellow).
7) *Zongo Comics* logo.

1996 SDCC Bongo Pins:
1) Marge Simpson — Marge smiling with her hair running off the top.
2) Bart Simpson — Bart's head inside Marge's hair.

3) Maggie Simpson — Maggie inside Marge's hair.
4) *Roswell* — Secret Saucer Society.
5) Radioactive Man — Official Member Radioactive Man's Thermonuclear Throng.

1997 SDCC Bongo Pins:
1) Homer Simpson — Honorary Member Sacred Order of the Stone Cutters.
2) Grandpa Simpson — Platoon Mascot of The Fighting Hellfish.
3) Apu — Kwik E Mart Employee of the Month.
4) *Roswell* — The Roswell Incident 1947-1997.

1998 SDCC Bongo Pins:
1) Moe — Uncle Moe's Family Feedbag Frequent Tipper Club.
2) *Fleener* — Mary Fleener comic from Zongo.
3) Julliene — Character from Roswell.
4) *Hopster's Tracks* — Stephanie Gladden's comic.

1998 Bongo Stickers:
1) Krusty — Acid Wash Mouth Rinse.
2) Krusty's Pork Slabs, in heavy gray sauce.
3) Cajun-Style Blackaned Krusty O's.

1999 SDCC Bongo Pins:
1) *The Simpsons Forever!*
2) Comic Book Guy — The Android's Dungeon: Honorary Dungeon Master.
3) Planet Express logo from *Futurama*.

2000 SDCC Bongo Pins
1) Krusty Fan Club
2) Bart Simpson (Bart on skateboard)
3) Get Bent! — Bender from *Futurama*

Bongo Comics promo pins from 1995 and 1996. Distributed at the San Diego Comic Convention. $4-6 each.

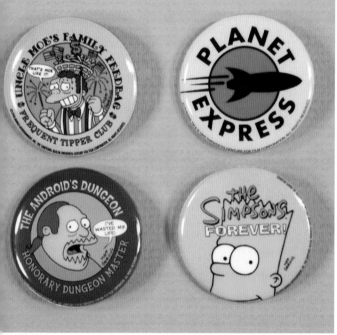

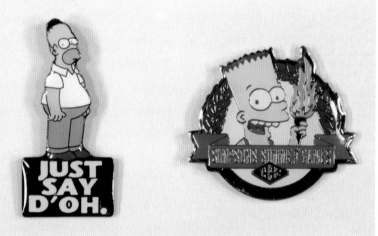

"Just Say D'oh" pin from Australia and "Simpsons Summer Games 1992" Olympics pin. $6-12 each.

Bongo Comics promo pins from 1998 and 1999. Distributed at the San Diego Comic Convention. See my first book for pictures of the 1997 pins. $4-6 each.

Two interesting promo pins: the first celebrates The Simpsons receiving their star on the Hollywood Walk of Fame and was distributed with the press kit for *The Simpsons Global Fanfest* (see Chapter 10). $12-16. The other is a replica of the Western Pacific Simpsons plane, probably handed out to employees and guests. $30-40.

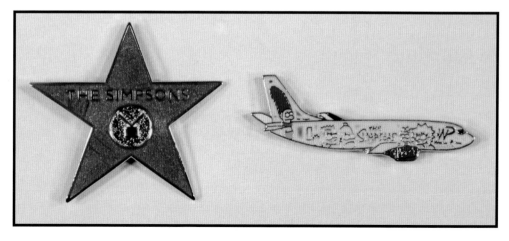

Lisa badge from Anything Goes, U.K.
$3-6. *Courtesy of Greg Joseph.*

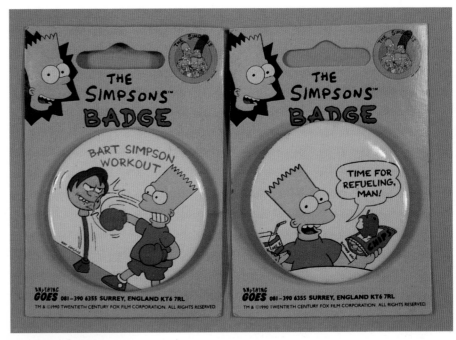

Bart badges from Anything Goes, U.K. $3-6 each.

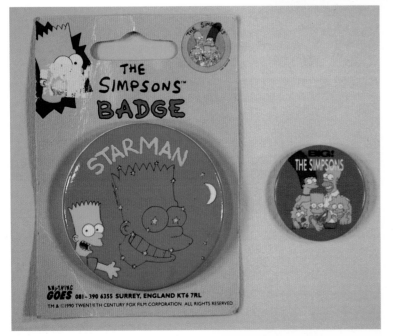

Bart "Starman" badge from Anything Goes, U.K.
$3-6. Unidentified promo pin from U.K. $3-6.

Bart 3-D pins from
Toonies, U.K. $6-10 each.

Chapter Nine: Trading Cards/Greeting Cards

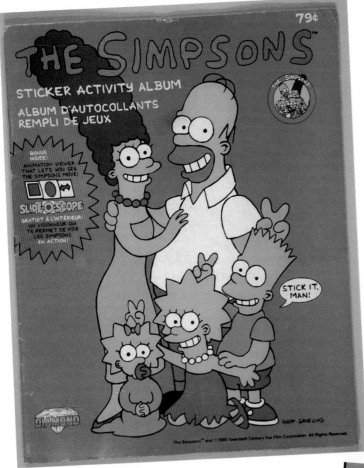

This Sticker Activity Album from Diamond had space for 150 stickers. $8-12.

Simpsons sticker pack. Diamond. $3-5.

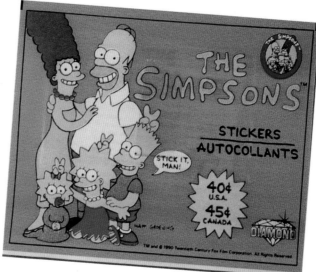

Some of the Diamond set's 150 stickers, 1990.

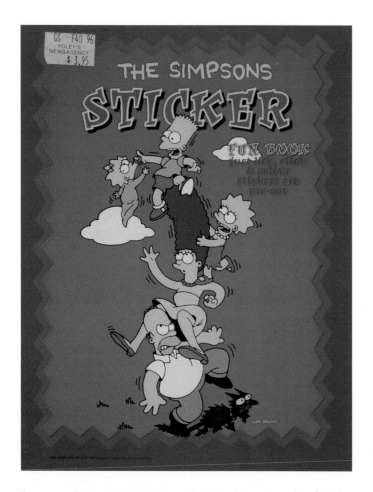

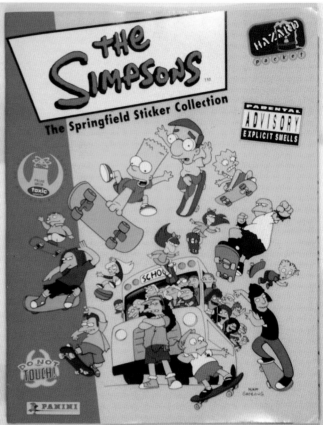

Simpsons Springfield Sticker Collection Book
from Panini, U.K. $8-12.

Simpsons Sticker Fun Book from Pancake Press, Australia. $5-10.

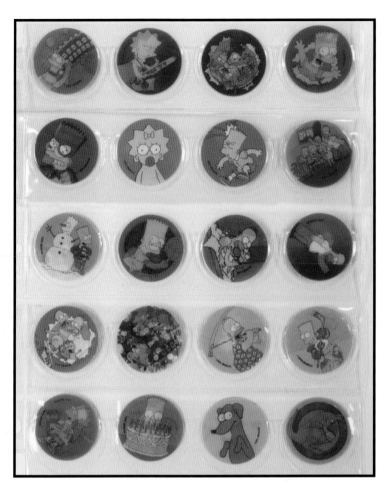

These "Magic Motion Tazos" hail from Australia and could be found in Frito-Lay products. There were forty in the complete set. $1-3 each, $20-30 for complete set.

More "Magic Motion Tazos."

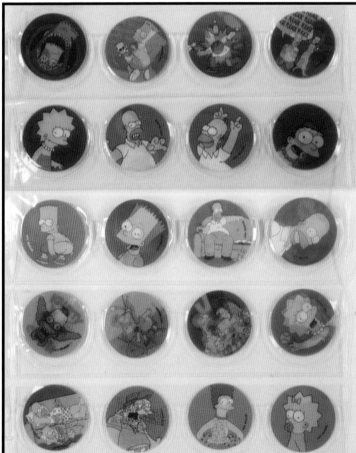

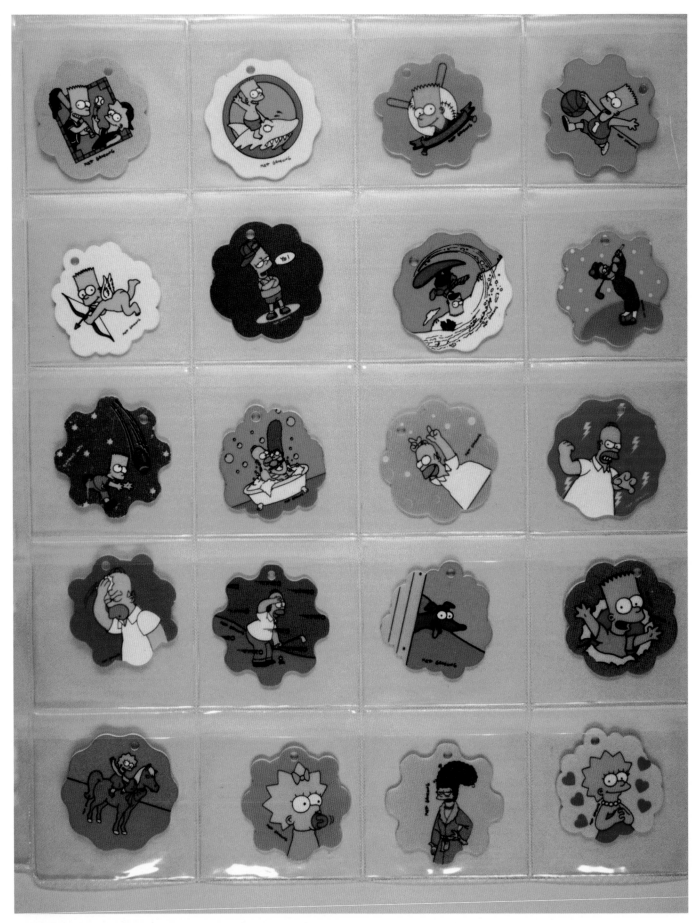

The 100 Simpsons caps in this set were available in bags of Croky chips in
Belgium. These are #1 through #20. $1-3 each, $70-90 for complete set.

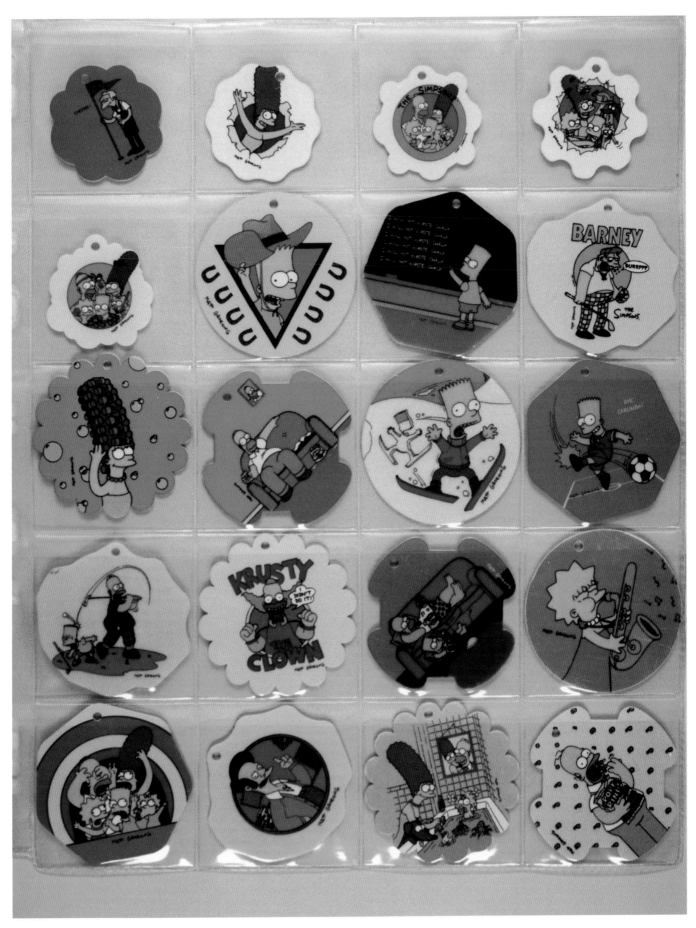

Croky caps, #21 through 40.

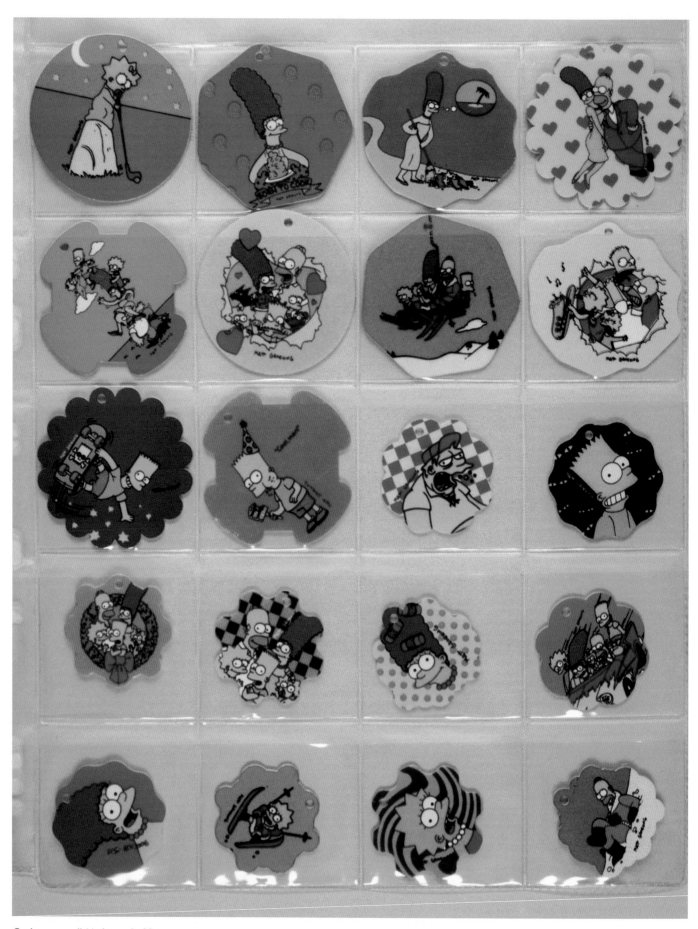

Croky caps, #41 through 60.

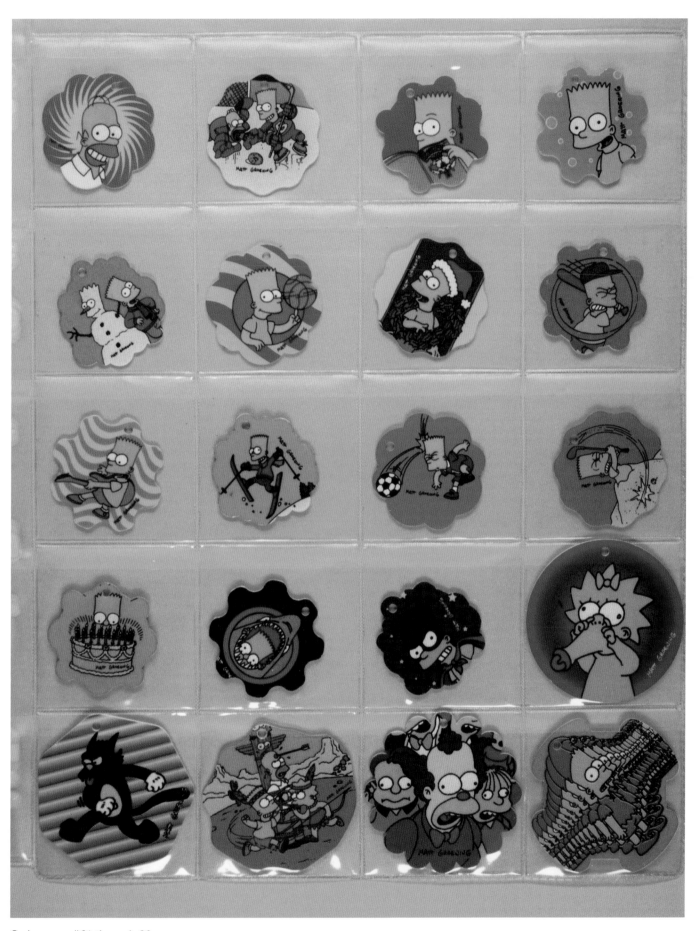

Croky caps, #61 through 80.

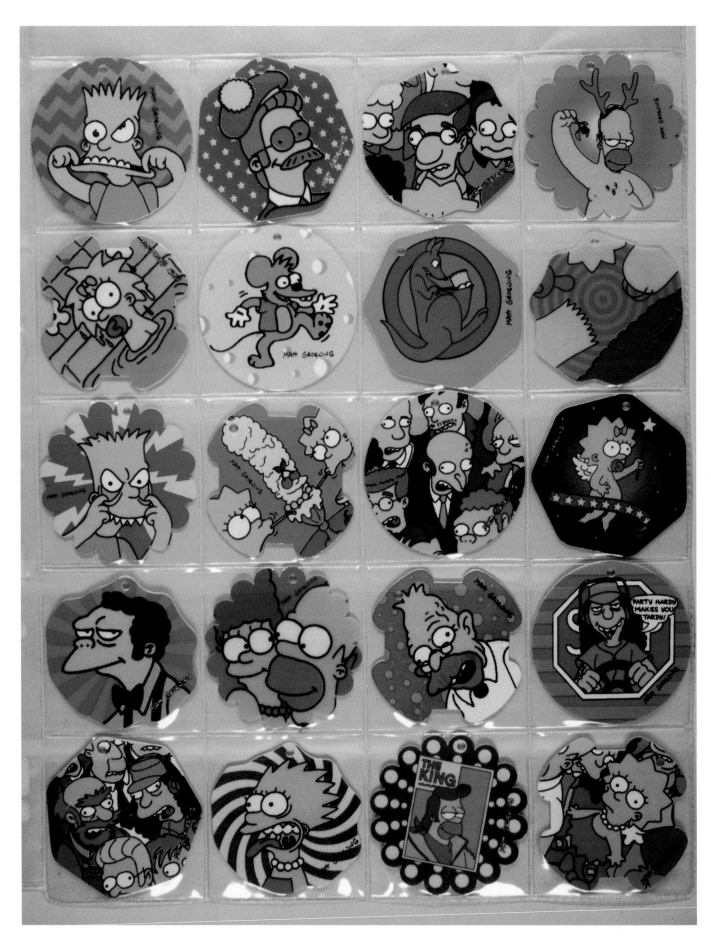

Croky caps, #81 through 100.

Glow-In-The Dark Glo-Caps from Australia. These are #1 through #20. $1-3 each, $30-50 for complete set.

Glo-Caps #21 through 40.

Glo-Caps #41 through 60.

CC's Chips in Australia offered these great 3-D cards, as well as an album to keep them in. Power Plant set, cards #1 through #9. $12-15 for set.

CC's Chips 3-D Bar-B-Que set, cards #10 through #18. $12-15 for set.

CC's Chips 3-D Underwater set, cards #19 thorough #30. $15-20 for set.

CC's Chips 3-D card #31. $2-4.

CC's Chips 3-D card #32. $2-4.

CC's Chips 3-D Puzzle and Collector Album, holds all 32 cards. Australia. $8-12.

Greeting cards from Gibson. $3-6 each.

Greeting cards from Gibson. $3-6 each.

Homer Simpson post cards from A Bigger Splash, U.K. $3-6 each.

Greeting cards from Portico Designs,
U.K. Each card comes with a free
magnet. $5-8 each.

Greeting cards from Portico Designs, U.K. Each card comes with a free badge. $5-8 each.

Greeting card from Portico Designs, U.K. $3-6. Party sign from Tonnerre, France, $3-6.

Chapter Ten: Promotional and Other

Krusty promo pin from Fox. $15-20.

Tickets to Itchy and Scratchy Land, "The Violentest Place On Earth!" The disclaimer on the ticket reads, "Management assumes no responsibility for any scratches, bruises, bleeding, scarring, clubbing, flailing, squishing, hacking, crunching, garroting, maiming, bone breaking, or disfiguration that may occur on the premises." Whew, that's a relief. Fox. $20-30.

Homerpalooza Backstage pass from Fox. $25-30.

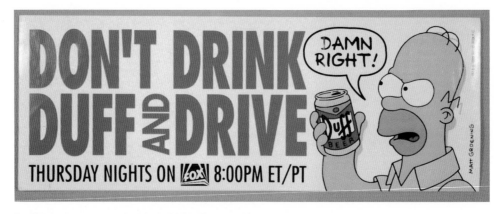

Duff Beer bumper sticker that obviously dates from when the show was on Thursday nights. Fox. $15-25.

Now here's a nice one. An actual gold (piece of paper shaped like a) record that celebrates the "musical contribution" of The Be Sharps and their hit single " 'Baby On Board' (which has sold a whole bunch of records)". Fox. $30-40.

Right:
Promo clock celebrating the show's 200th episode. Fox. $20-30.

Promo T-shirt celebrating *The Simpsons* beating the record held by *The Flintstones* as longest-running prime-time animated series. Fox. $15-20.

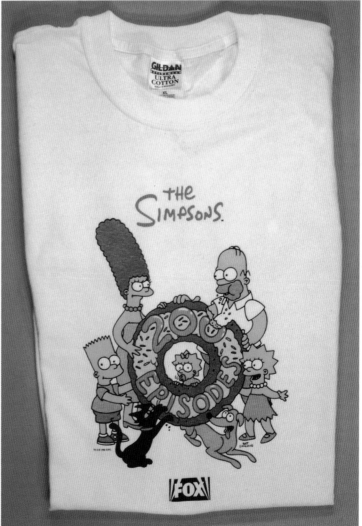

Promo T-shirt celebrating the show's 200th episode. Fox. $15-20.

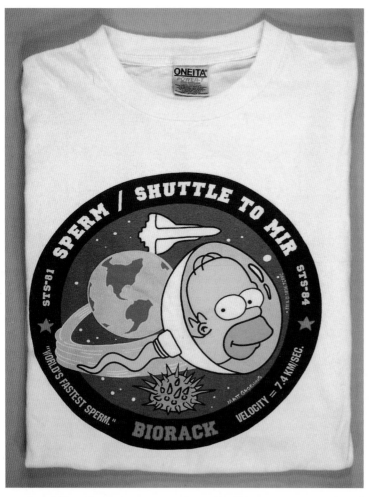

A real-life space experiment involving the MIR space station and sea urchins inspired this T-shirt, which was created to give out to the crew. There was also a sew-on patch version. $25-30.

Press kit for the "Win The Home Of The Simpsons" contest. $12-15.

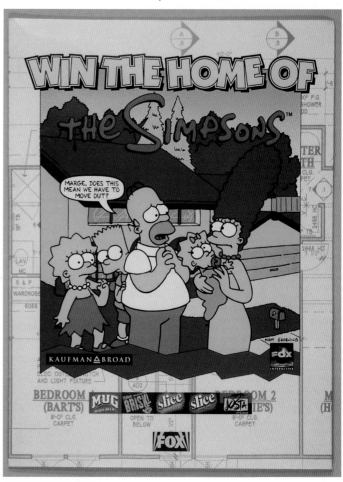

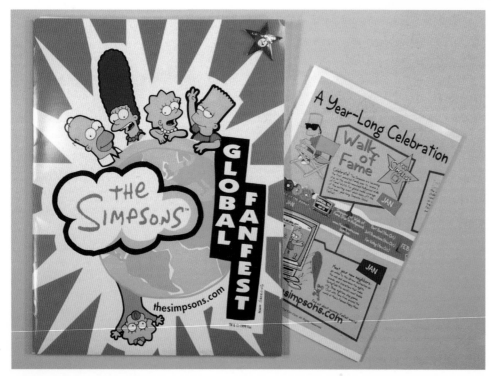

Press kit for The Simpsons Global Fanfest. Notice the star-shaped pin in the corner that celebrated the show's star on the Hollywood Walk of Fame. Fox. $25-30, with pin.

Lisa Simpson album flat for *Go Simpsonic With The Simpsons!* Rhino. $3-5.

From the 7-11 *Simpsons* promotion, July/August 2000: "Biggest Big Bite" box, $1-3. Global Fanfest Trivia Contest cards, $1-3. Global Fanfest badge (reading "January-October"), $8-12.

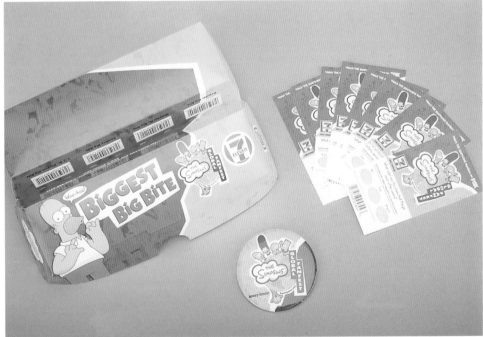

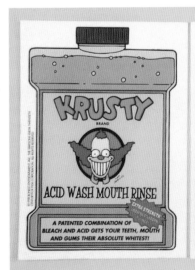
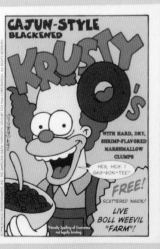
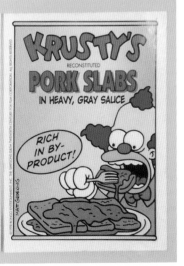

Bongo Comics promo stickers distributed at the San Diego Comic Convention, 1998. $3-5 each.

Promo strip for candy display from U.K. $3-5.

Butterfinger BB's display from Nestle's. $30-40.

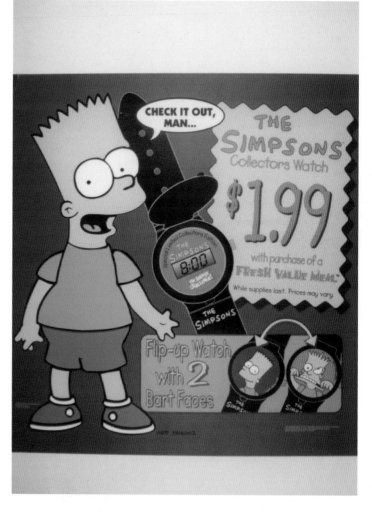

Hard plastic display card for Bart Simpson collectible watch. Subway. $20-30.

Window cling for Bart Simpson collectible watch from Subway. $15-20.

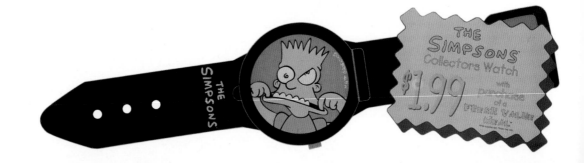

Homer Simpson cap from Intel. $15-20.

Homer Simpson mug from Intel. $12-15.

Homer Simpson mousepad from Intel. $12-15.

Homer Simpson T-shirt
from Intel. $12-15.

Promo booklet for Simpsons premiums
from Roda/Resi Products, Belgium. $6-10.

Promo booklet for Simpsons Comics. Dino, Germany. $6-10.

Butterfinger contest sticker
from Nestle's. $5-8.

Promo post card for Fox affiliate. $3-5.

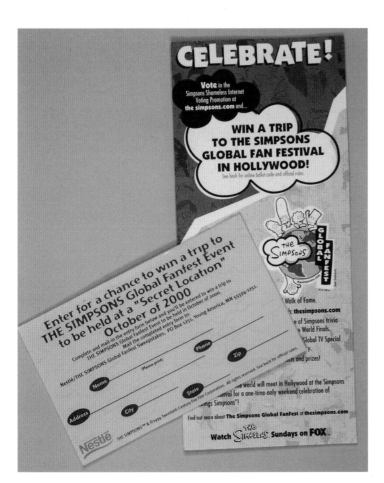

In March of 2000, Suncoast Video stores tied in their "Simpsons Global Fanfest" contest with the upcoming Academy Awards and came up with this amusing series of large posters that were on display for the entire month. In addition, there were exclusive Bart and Homer T-shirts that reproduced the art, as well as an exclusive mug (see Chapter Three). $15-20.

Global Fanfest contest entry forms from Nestle's and Suncoast. $1-3.

Bart Simpson Suncoast poster. $15-20.

Exclusive Homer T-shirt from Suncoast Video, featuring art from their "Academy Award" campaign. $12-15.

Lisa Simpson Suncoast poster. $15-20.

Maggie Simpson Suncoast poster. $15-20.

Simpsons Global Fanfest
poster. Suncoast. $15-20.

Well, that's gonna do it until the next Millennywhoozis. You know, the last time we had a Millennyhoo, there was darkness everywhere because James Madison took a bite out of the sun, which was called an eclair in those days, and there were pretty girls on the calendars, but there were only three months! Of course, none of them had names in those days . . . which made it hard to get a dentist appointment. Thank goodness we didn't have teeth! Now, at that time . . . hey! Where'd everybody go?